IMAGES
of America

CAMDEN

Cheryl Baisden

IMAGES
of America

CAMDEN

Cheryl L. Baisden

ARCADIA

Published by Arcadia Publishing
Charleston SC, Chicago IL, Portsmouth NH, San Francisco CA

Printed in the United States of America

Library of Congress Catalog Card Number: 2005936494

For all general information contact Arcadia Publishing at:
Telephone 843-853-2070
Fax 843-853-0044
E-mail sales@arcadiapublishing.com
For customer service and orders:
Toll-Free 1-888-313-2665

Visit us on the Internet at http://www.arcadiapublishing.com

CONTENTS

ACKNOWLEDGMENTS

This book would not have been possible without the assistance and support of several people. Ruth Bogutz of the Tri-County Jewish Historical Society was kind enough to allow the use of a number of photographs from her collection. Sue Brennan of the Fairview Historical Society provided photographs illustrating the construction of Yorkship Village and helped locate others who contributed to the book. The *Catholic Star Herald*'s longtime staffer Jim McBride, with his wall of filing cabinets crammed with old photographs and newspaper clippings, was an invaluable source of material. Jon'a Meyer of Rutgers University took the time to share her fine collection of Rutgers and Camden memorabilia. Barbara Miller of Cooper University Hospital allowed access to the facility's wonderful archival materials, as did Scott Share of Lourdes Health System. Doug Rauschenberger, Haddonfield Public Library director, granted special access to the library's fine collection of Camden photographs from the 1940s and 1950s, and former Camden resident Benedict Tisa contributed numerous postcards from his extensive collection. Grateful acknowledgment is made to the L. Ron Hubbard Library for permission to reproduce sections from the copyrighted works of L. Ron Hubbard.

A very special thank-you is extended to B. J. Swartz, who provided several photographs and invaluable contacts around the city, and to Phil Cohen, Camden's unofficial Internet historian, who not only shared his knowledge of the city but also reached out to others who, as a result, contributed to this book. Last, but not least, this book would not have been possible without the assistance of Janet Gallo.

INTRODUCTION

It was the city of Philadelphia that first transformed the stretch of land along the eastern shore of the Delaware River into prime property. As the Quaker city grew and prospered, building materials, produce, and other essentials, as well as people, needed to be transported across the river, and savvy businessmen like William Cooper saw the opportunity to launch ferry services along the New Jersey riverbank as early as the 1680s.

Nearly a century passed before the territory was christened Camden by Cooper's great-grandson Jacob, who in 1773 dropped the name Cooper's Ferry in honor of England's first Earl of Camden, an opponent of the British Crown's taxation of American colonists without representation. By the time it was officially incorporated in 1828, Camden had grown from little more than a handful of ferry operations into a thriving rural settlement of 1,143 residents.

By the close of the Civil War, Camden, by then the county seat, had won a reputation as the center of economic and political life in southern New Jersey. Steam locomotives, horse-drawn trolleys, and ferries shuttled hordes of workers, shoppers, tourists, and couples out for an evening's entertainment to the bustling city of close to 15,000. And as its reputation as the "Biggest Little City in the World" continued to grow, so did the opportunities Camden had to offer.

Food-processing pioneer Campbell Soup Company; recording innovator Victor Talking Machine Company (later RCA); the nation's first steel pen manufacturer, Esterbrook Pens; industrial giant New York Shipbuilding Corporation; and close to 150 other manufacturers—many touted as some of the largest in the nation—erected factories around the city. Business was booming; in 1926 alone, Camden's banks handled more than $750 million in transactions for businesses and private customers.

Modest brick and stone row homes to house Camden's swelling workforce, which was heavily immigrant-based, seemed to pop up overnight, along with impressive residences to accommodate the city's growing middle- and upper-class population. Before long, Camden's tight-knit ethnic enclaves—filled with immigrants working their way toward the American dream—were flourishing. Italians, Irish, Germans, Poles, and Jews found their little neighborhoods comfortable havens in their new homeland, filled with familiar chatter, old customs, and family-run shops. By all accounts, Camden offered the best of both worlds—the economic opportunity of a major urban center and the welcoming feel of a rural village.

Its residents were proud to call Camden home, and thousands of visitors flocked, to what by 1950 had become the state's fifth largest city, to shop, conduct business, patronize the city's restaurants and theaters, and attend civic, cultural, and sporting events at the convention center,

armory, and magnificent Walt Whitman Hotel. It seemed the city poet Walt Whitman once declared "invincible" was, in fact, just that.

The tide turned in the 1950s, as young families began settling into newly constructed housing developments in the suburbs, and the city's industrial base began to erode. When the Cherry Hill Mall—at the time the largest indoor shopping mall on the east coast—opened for business in 1961, Camden's business district began to fade as well. What followed was a virtual exodus, but today a renewal is underway on many fronts. In the meantime, for those who remember the glory days, the true spirit of Camden is preserved within these pages.

One

THE ROAD TO RICHES

Situated along the eastern shore of the Delaware River, Camden's early success hinged on its proximity to the bustling city of Philadelphia. The area that in 1828 was incorporated as Camden began as the site of a ferry launch, but by 1926, with a new bridge spanning the river, Camden had become an economic powerhouse in its own right.

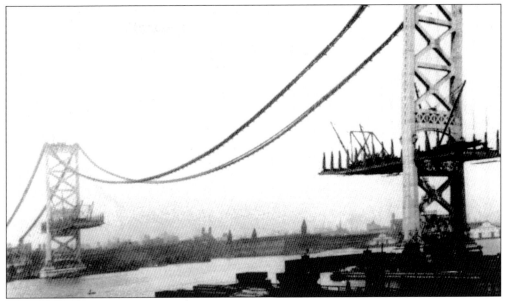

Constructing a bridge between Camden and Philadelphia had been discussed since 1818, but it took over 100 years and the automobile's growing popularity to develop a viable plan. With motorists returning from the Jersey shore waiting hours for ferries, it was time to act. Delaware River Bridge construction began in January 1922. The two main spans and wood-planked footbridge seen here were among the project's first phases. (Courtesy Delaware River Port Authority.)

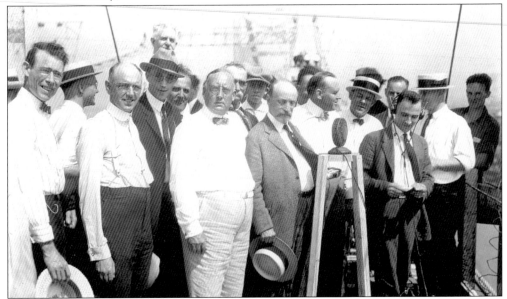

Delaware River Bridge Joint Commission members crossed the unsteady footbridge on August 8, 1924. The crossing was marked at mid-span with a radio addresses by Chief Engineer Ralph Modjeski, former Philadelphia Mayor Thomas Smith, and Commissioners Frank Suplee and Samuel Lewis. When the group reached Camden, one gentleman compared the harrowing experience to George Washington's historic Delaware crossing, noting that the general "had nothing on us." (Courtesy Delaware River Port Authority.)

10

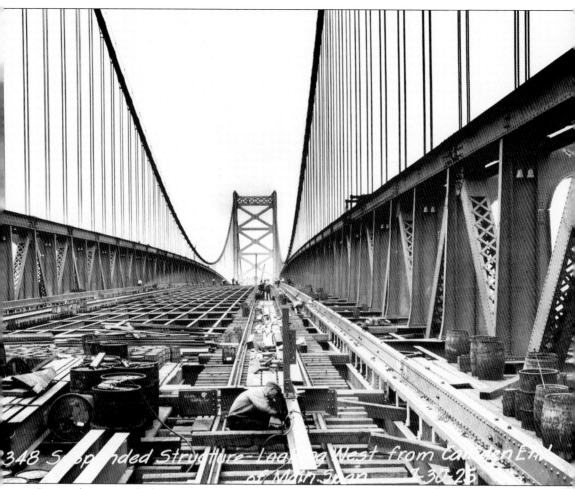

348 Suspended Structure Looking West from Camden End or Main Span 1-30-25

Just under a year before its scheduled opening, work continues on the suspended structure designed to support the bridge's 1,750-foot-long center span. Viewed as an engineering marvel of its day, the Delaware River Bridge (renamed the Benjamin Franklin Bridge in 1955) was the world's longest suspension bridge when it opened in July 1926. In the rush to complete the project, labor peaked at 1,300 men in the summer of 1925, when this photograph was taken, and a total of 15 workers lost their lives in a series of construction accidents. Among the fatalities was Edward M. Church, who, having spent his last dime the week before his death, became dizzy from lack of food and fell 60 feet. Criticism arose regarding hiring policies when it was discovered that Church only had one eye. (Courtesy Delaware River Port Authority.)

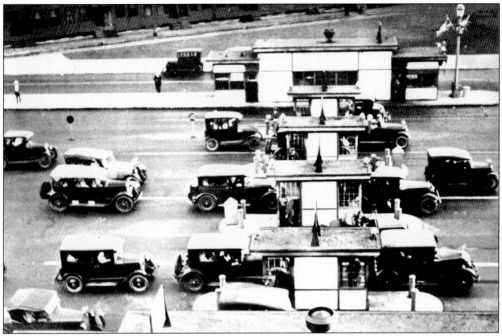

The bridge opened to pedestrians at 1:00 p.m. on July 1, 1926, and 100,000 people crossed by 7:00 p.m., including a woman who climbed off the footpath threatening to jump. Vehicular traffic began at midnight, with 3,850 crossings the first hour. Within 24 hours, 32,000 travelers had paid tolls of 25¢ per car; 15¢ per horse and rider; and 20¢ to lead a horse, mule, cow, hog, or sheep across. (Courtesy Delaware River Port Authority.)

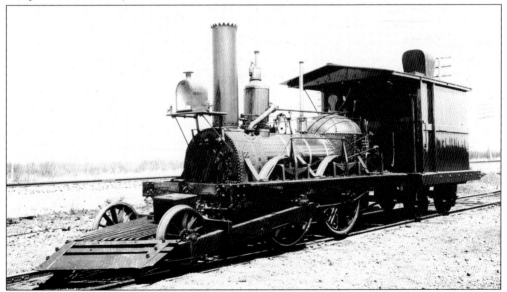

At one time the country's longest rail line, the Camden and Amboy Railroad was chartered in 1835 and purchased the famous steam locomotive John Bull from Britain's Robert Stephenson to transport passengers and freight until 1866. Shipped disassembled, the engine was reconstructed in 11 days by a Bordentown, New Jersey, mechanic and his crew, none of whom had ever seen a locomotive. (Courtesy Library of Congress.)

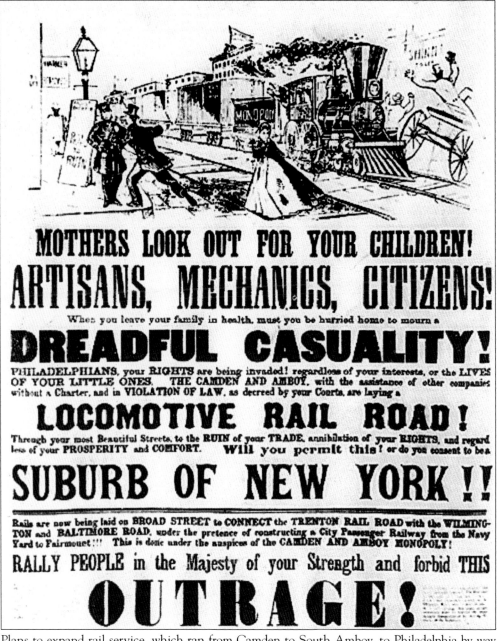

MOTHERS LOOK OUT FOR YOUR CHILDREN!
ARTISANS, MECHANICS, CITIZENS!

When you leave your family in health, must you be hurried home to mourn a

DREADFUL CASUALITY!

PHILADELPHIANS, your RIGHTS are being invaded! regardless of your interests, or the LIVES OF YOUR LITTLE ONES. THE CAMDEN AND AMBOY, with the assistance of other companies without a Charter, and in VIOLATION OF LAW, as decreed by your Courts, are laying a

LOCOMOTIVE RAIL ROAD!

Through your most Beautiful Streets, to the RUIN of your TRADE, annihilation of your RIGHTS, and regardless of your PROSPERITY and COMFORT. Will you permit this? or do you consent to be a

SUBURB OF NEW YORK !!

Rails are now being laid on BROAD STREET to CONNECT the TRENTON RAIL ROAD with the WILMINGTON and BALTIMORE ROAD, under the pretence of constructing a City Passenger Railway from the Navy Yard to Fairmount!!! This is done under the auspices of the CAMDEN AND AMBOY MONOPOLY!

RALLY PEOPLE in the Majesty of your Strength and forbid THIS
OUTRAGE!

Plans to expand rail service, which ran from Camden to South Amboy, to Philadelphia by way of Trenton were met with opposition when the Camden and Amboy Railroad sought to expand service in 1839. As this poster illustrates, the proposed expansion was decried as a threat to public safety, peace and prosperity, and local trade. While the poster may have been a bit dramatic, there were legitimate safety issues connected with the Camden and Amboy line as far as the public was concerned. In the early days, pedestrian fatalities were so high in Camden that a flagman was hired to walk 50 to 100 yards ahead of the locomotive to shoo people off the tracks. (Courtesy National Archives and Records Administration, Still Picture Records.)

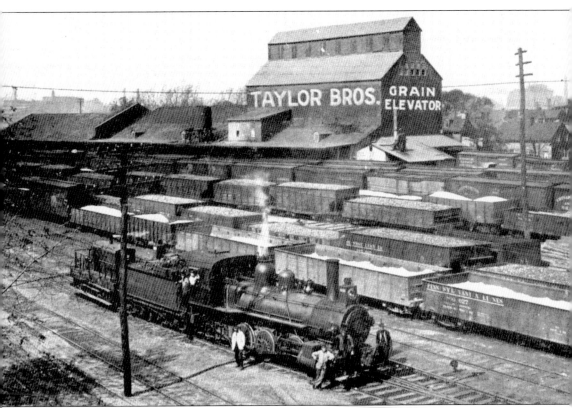

Seaside excursions prompted the establishment of the Camden and Atlantic Railroad in 1852. The rail line, which shuttled Camden and Philadelphia middle-class families to the Jersey shore, led to the development of Atlantic City as a seaside resort. In the off season, the rail line focused on transporting goods from Camden, including grains, seeds, hay, and wheat from Taylor Brothers Grain Elevator and Warehouse, pictured here at Front and Market Streets.

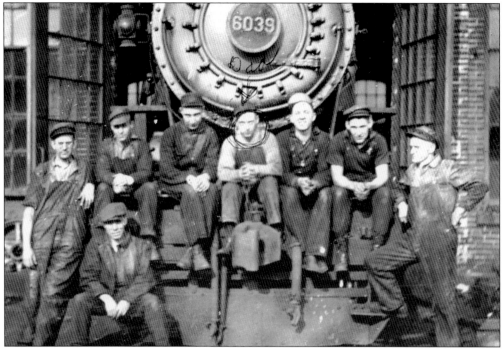

By 1881, eight railroads linked Camden to Philadelphia, Trenton, New York, Atlantic City, and western regions. The transportation network was the catalyst for Camden's industrial growth in the late 19th century. This pre–World War II photograph was most likely taken at Pennsylvania Railroad's Pavonia Car Works and Freight Yard (at Twenty-seventh and Howell Streets), which opened in 1888 and drew skilled workers to the city as engineers, machinists, motormen, mechanics, car makers, and telegraph operators. (Courtesy Bernie Rieck.)

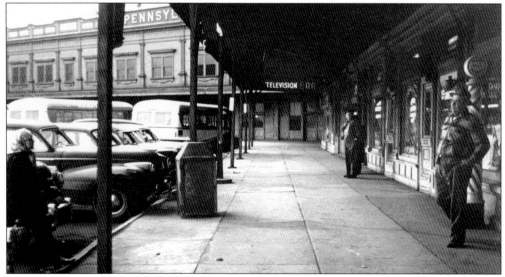

The Pennsylvania Railroad Station, along the Delaware River at Federal and Market Streets, pictured here in 1951, operated as a hub of transportation for the city. From the waterfront station, Camden's workforce and those out to enjoy top-notch dining, theaters, and shopping could catch a train, trolley, jitney, or ferry. (Courtesy Haddonfield Public Library.)

15

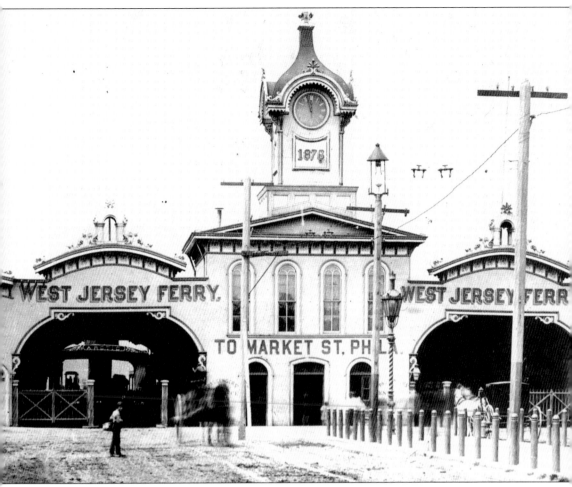

The West Jersey Ferry was established on the waterfront at Market Street in 1800 by Abraham Browning, leading to rapid development along the street, which had been little more than vacant land. The ferry house, which included a waiting room in the center and offices on the sides, was dismantled in 1876. In keeping with the tradition of the day, a pleasure garden (equipped with food, drink, and various entertainment facilities) was located adjacent to the ferry landing along the Delaware River, shaded by a number of willow trees.

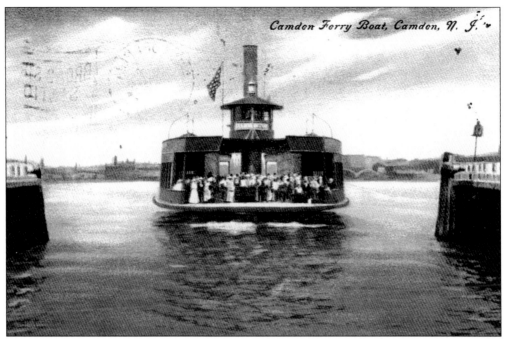

The city's first commercial ferry service between Philadelphia and what would become Camden was established in 1688 at the end of Cooper Street. Over the next two-and-a-half centuries, transporting passengers and goods across the Delaware River became a lucrative business, with the city at one point boasting one private and six public ferry services.

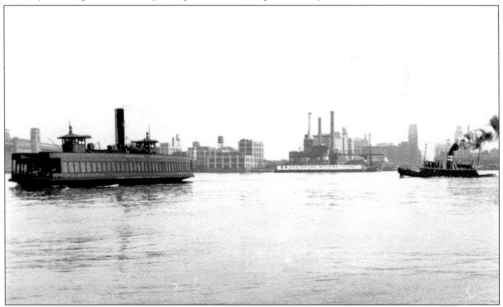

In 1836, John Mickle founded what would become the city's longest operating ferry service, the Philadelphia and Camden Steamship Ferry Company, pictured here in full swing in the 1940s, transporting passengers and cargo from the Federal Street ferry house. In 1865, rates were set at 5¢ for adults and 2¢ for children between the ages of 4 and 12. Regulars could purchase 34 rides at the special rate of $1. (Courtesy Haddonfield Public Library.)

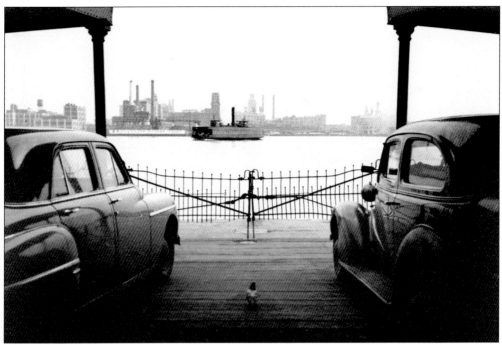

Camden's ferry traffic began declining once the Delaware River Bridge opened in 1926. On March 31, 1952, at the age of 116, Camden's last water service—the Philadelphia and Camden Steamship Ferry Company—closed its doors. "For the first time in 264 years, Camdenites and Philadelphians will find themselves tonight without a ferry line between the two cities," reported the *Courier-Post*. This photograph was taken just months before ferry service ceased. (Courtesy Haddonfield Public Library.)

Industrial Camden entered the Pacific trade markets when the Municipal Pier, located at the foot of Spruce Street, began freight steamship service to the region. The first shipment of Camden cargo left the four-year-old pier on March 24, 1925, aboard the freighter *Orleans*.

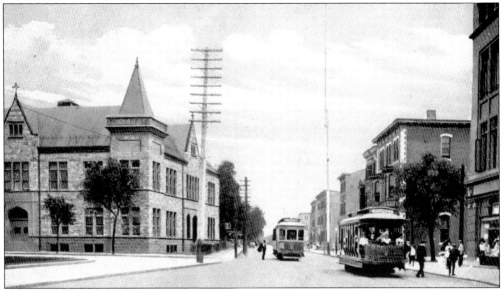

The city's trolley service began as a horse-drawn system known as the Camden Horse Railroad, running along gravel roadways in 1871, and was converted to a popular electric trolley service plotted along newly paved streets shortly before World War I. The first driver of the electrified line was Camden resident William Heckenhorn.

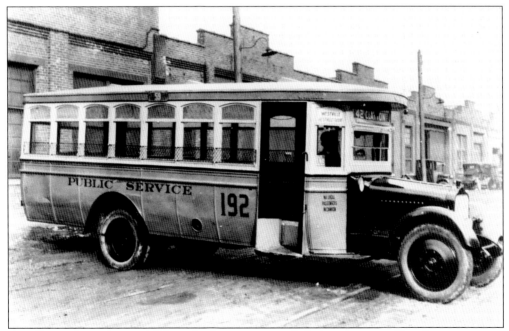

A trolley strike in August 1923 resulted in a strong push for bus service in Camden to transport workers and shoppers throughout the city and into surrounding communities. In this photograph, taken around 1930, Public Service Railway Company bus 192 stands in front of the line's Mount Ephraim Avenue garage. The driver is about to begin his route to Clayton via Route 42. (Courtesy Library of Congress, Prints and Photographs Division.)

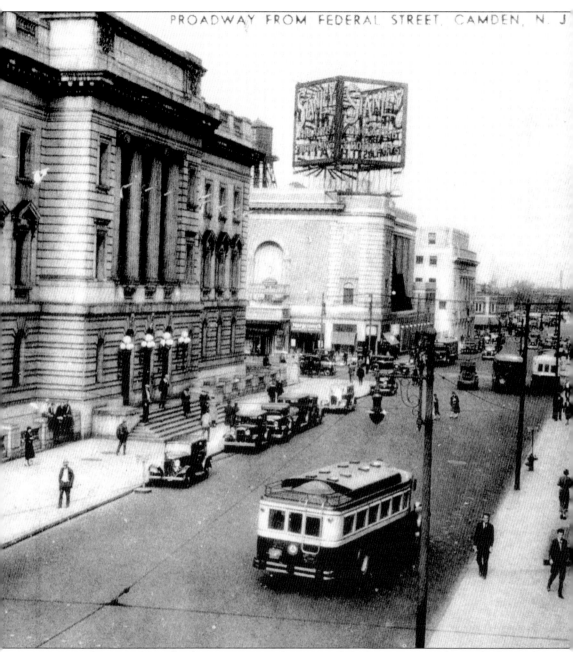

In 1901, the City of Camden began requiring that automobile drivers register their vehicles, and the speed limit was set at 10 miles per hour. As the automobile continued gaining popularity, as seen here along Broadway from Federal Street, some residents worried about the increasing speed of traffic along city streets. In 1904, one city newspaper reported: "The automobile is abroad in the land and seems destined to stay." The writer noted that some towns between Camden and Atlantic City were considering arming police with guns "to be used in puncturing the tires and machinery of the offending vehicles." A mere six years later, cruising around town in their parents' new car or an old jalopy had become a favorite way for the city's youth to spend summer evenings.

Two

A PLACE IN HISTORY

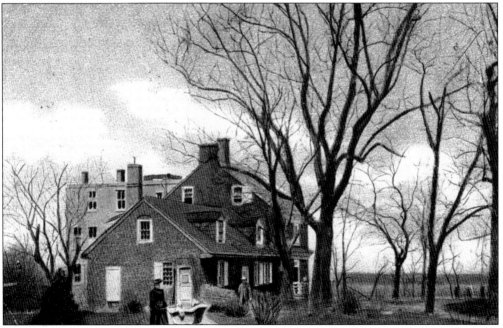

William Cooper, Camden's first settler, built his Pyne Poynt mansion on 300 acres of pine forest at Seventh and York Streets in 1683. Originally the site of an Indian campground, the property later became a library and park. Legend claimed that while Camden was still a village, and pirates Captain Kidd and Blackbeard frequented the area, a mysterious ship was spotted anchored along the shoreline for days, leading generations of local children to scour the banks for buried treasure.

Benjamin Cooper built this stone house as a ferry tavern at Point and Erie Streets in North Camden in 1734. Shown here around 1898, the house was commandeered by British Gen. James Abercrombie and used as his headquarters during the American Revolution in 1777 and 1778. In 1883, the home, known as the Old Yellow House, served as a boardinghouse and saloon called the Old Stone Jug and later as the office for the Mathis Shipyard. (Courtesy Gloucester County Historical Society.)

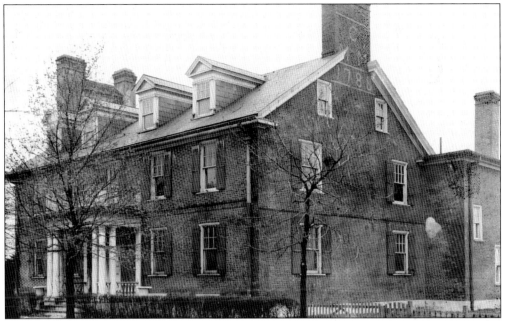

Originally constructed in 1726 by Joseph Cooper Jr., grandson of the city's first European settler, Pomona Hall now serves as the home of the Camden County Historical Society. The brick mansion at Park Boulevard and Euclid Avenue was enlarged in 1788 by Marmaduke Cooper and was once the main house for a 400-acre plantation. (Courtesy Library of Congress, Prints and Photographs Division.)

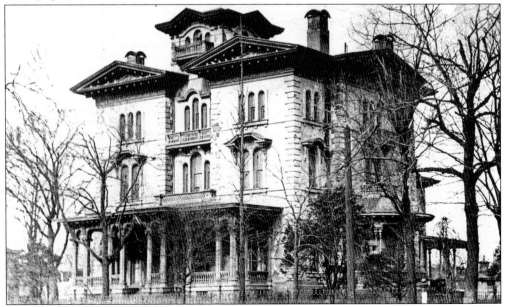

Joseph W. Cooper built this elaborate home at Front and State Streets in 1853, surrounding it with luxurious gardens and ornamental fountains. The site of many formal social functions and charity events, the mansion was the largest, most advanced house in the city. Among Camden residents, it was known as Cooper's Folly because of its opulence. It was razed by Victor Talking Machine Company in 1925. (Courtesy Gloucester County Historical Society.)

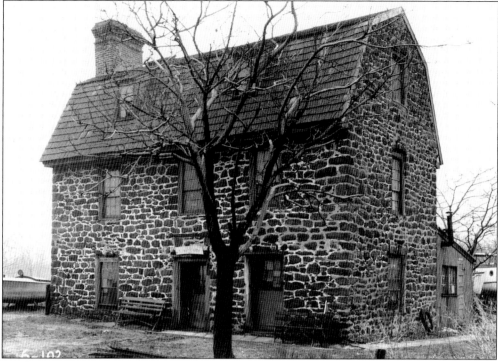

The Joseph Nicholson House, built in 1696, sat along the banks of the Cooper River on what is now Admiral Wilson Boulevard. The first glass windowpanes in America are said to have been designed for this fieldstone home, which was the oldest surviving house in the city when it was razed in 1948. (Courtesy Library of Congress, Prints and Photographs Division.)

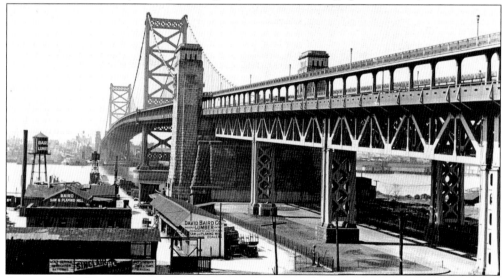

As a young Irish immigrant in the 1850s, David Baird worked as a $6-a-month farmhand and rafted logs on the Susquehanna River before founding his Camden lumber company in the early 1870s. Steeping himself in local Republican affairs, he became a political powerhouse and by 1918 had won a seat in the U.S. Senate. The riverfront business he founded is pictured here in the 1940s. (Courtesy Haddonfield Public Library.)

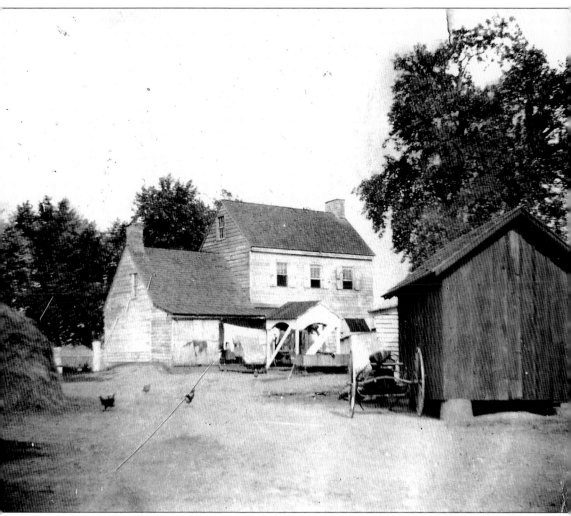

The Richard Jordan House on Chestnut Street, in what became downtown Camden, was home to the prominent Quaker minister who settled here in 1809. Jordan preached internationally against slavery beginning in the 1830s and reportedly sparked the political debate that led to the Civil War. The image of his Camden homestead, pictured here in 1897, was reproduced by Staffordshire potters on plates that became popular with Quaker families in the 1830s. (Courtesy Gloucester County Historical Society.)

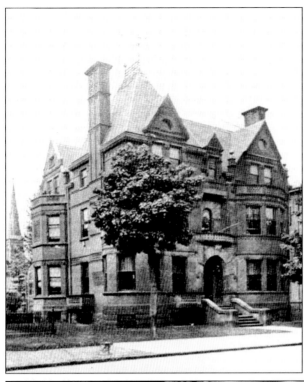

Decorated Civil War hero William J. Sewell called this mansion at Fifth and Linden Streets home beginning in 1860. After serving as commander of the 5th New Jersey Volunteer Infantry in the Second Battle of Bull Run and the Gettysburg conflict, Sewell became the most powerful railroad executive and real estate developer in South Jersey, as well as a U.S. Senator. Several years after his death in 1901, the mansion became Bellevue Hospital, serving a private clientele.

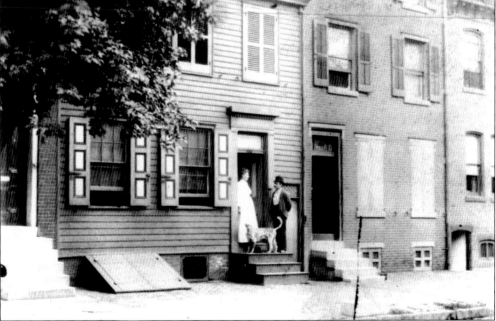

The internationally recognized poet Walt Whitman bought this modest row home at 328 Mickle Boulevard for $1,750 in 1884. Purchased with royalties from his highly successful work *Leaves of Grass*, it was the only home Whitman ever owned and was visited by such literary luminaries as Charles Dickens and Oscar Wilde. The visitor being greeted here by Whitman's housekeeper in this 1890 photograph is unidentified. (Courtesy Library of Congress, Feinberg-Whitman Collection.)

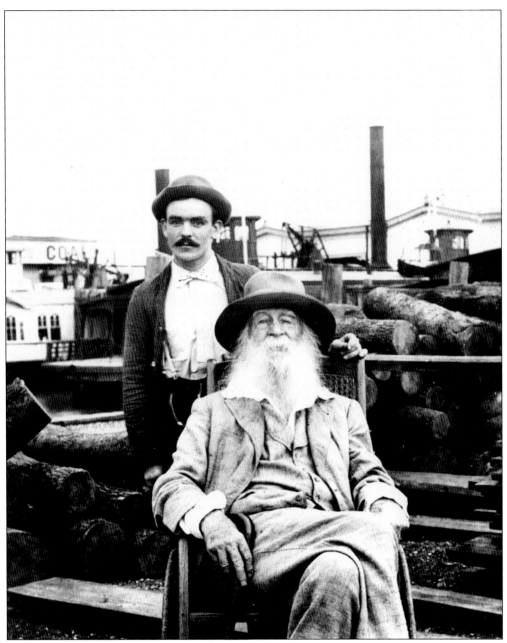

Walt Whitman, pictured here with personal nurse Warren Fritzenger in 1890 (two years before his death at age 72), regularly enjoyed afternoon strolls on the wharf near his home. He first settled in Camden in 1873, moving into his brother's Stevens Street house following a stroke. Referring to his 17 years in Camden as the happiest period of his life, Whitman wrote: "Camden was originally an accident, but I shall never be sorry I was left over in Camden. It has brought me blessed returns." (Courtesy Library of Congress, Prints and Photographs Division.)

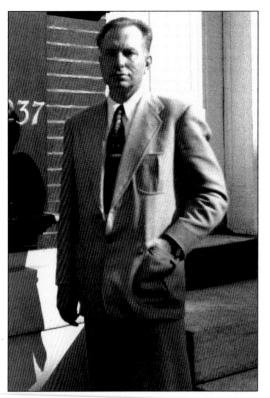

Author and Scientology founder L. Ron Hubbard, pictured here in 1953, delivered a total of 151 lectures at 726 Cooper Street and 507 Market Street in Camden between October and December 1953. Hubbard's clinical courses in Camden were among the earliest Scientology professional training courses, signaling a transition from Dianetics, dealing with the human mind, to the applied religious philosophy of Scientology, Hubbard's research discoveries of the human spirit. They became the basis for the formation of the church in 1954. (Courtesy L. Ron Hubbard Library.)

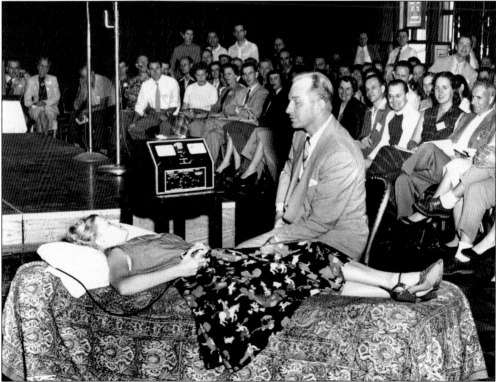

Three

CAPTAINS OF INDUSTRY

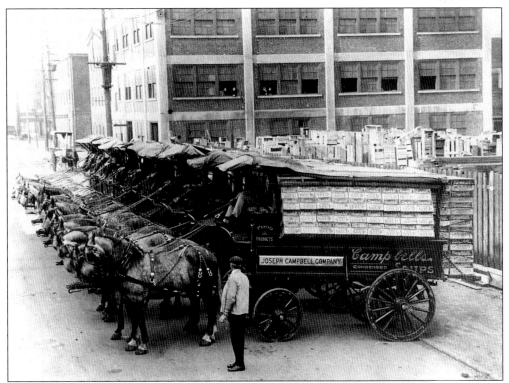

Horse-drawn wagons, each stocked with 304 cases of condensed soup, prepare to leave the Joseph Campbell Company at Second and Market Streets. In 1897, when Dr. John T. Dorrance developed the formula for condensed soup, the Camden company produced 10 cases a week. A mere eight years later, in 1905, the company was churning out 20 million cans annually. (Courtesy Campbell Soup Company.)

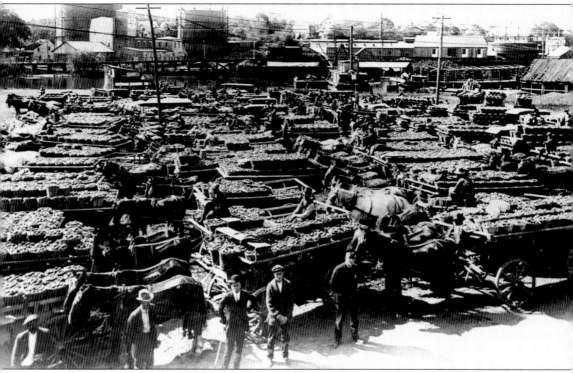

South Jersey farmers wait in line to deliver tomatoes to Campbell Soup Company around 1910. The wagons, each carrying between three and four tons of produce, lined Camden's roadways from late summer through the end of October. With the first farmers arriving before daybreak along Second Street, the line of traffic reportedly often stretched for nine miles. (Courtesy Campbell Soup Company.)

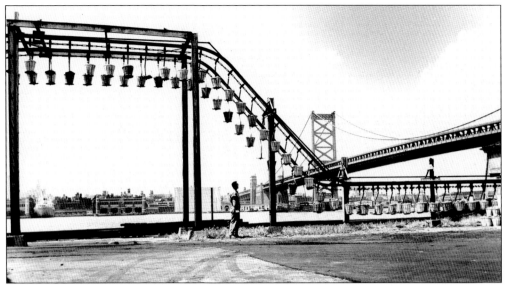

The contents of the first tomato wagon would be accepted at Campbell Soup's loading dock at 5:45 a.m., and, after an initial quality inspection to determine the farmer's pay scale, would travel on this lift into the factory. Once inside, the produce would undergo a series of washings before facing a more thorough inspection and processing. (Courtesy Campbell Soup Company.)

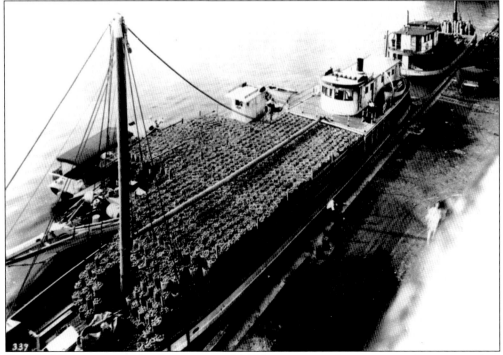

Campbell Soup contracted with an estimated 2,000 area growers for tomatoes each year, providing their own special seeds to guarantee consistency. In this early 1930s photograph, a load of tomatoes arrives by barge along the Delaware River docks. (Courtesy Campbell Soup Company.)

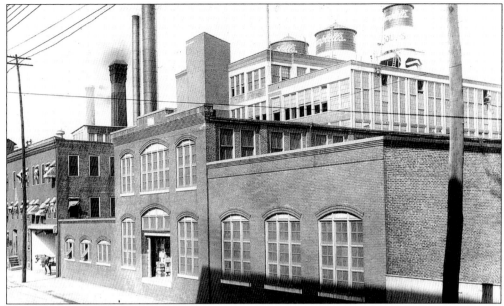

Founded in 1869, the Joseph Campbell Preserve Company entered the business arena packing peas and tomatoes in Camden. In 1897, it launched the product that brought it fame and fortune, condensed soup. Campbell's five original varieties—tomato, consommé, vegetable, chicken, and oxtail—sold for 10¢ a can compared to the 32¢ charged by non-condensed brands. Pictured here in 1916, the preserve company formally became the Campbell Soup Company in 1921. (Courtesy Campbell Soup Company.)

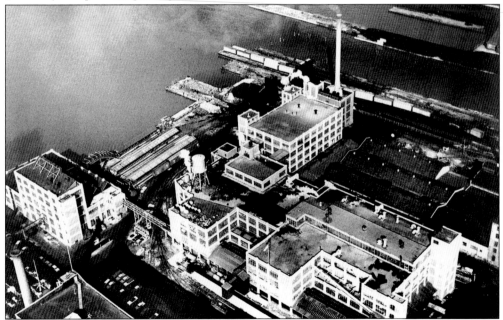

In the early 1920s, Campbell Soup Company built Plant No. 2, once known as the greatest industrial canning plant in the world, to handle its massive tomato pulp processing operation. By 1959, when this photograph was taken, the plant also processed tomato juice and pork and beans. (Courtesy Campbell Soup Company.)

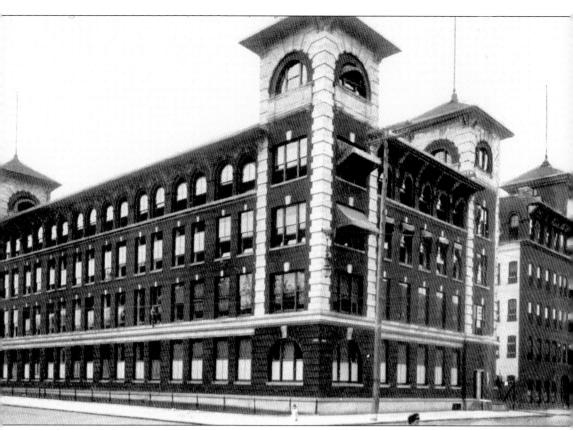

Camden repair shop owner Eldridge R. Johnson incorporated Victor Talking Machine Company in 1901. The Front Street business was launched when Johnson was asked to repair a talking machine that played Thomas Edison's cylinder-style recordings. Johnson decided to develop a phonograph that used disk-style recordings, and Victor Talking Machine Company soon became the world's largest producer of flat phonographic records, a format that swept the industry. In no time, Victor was drawing musical artists from around the world to its Camden studios and fielding millions of letters from fans seeking autographed photographs of their favorite performers. In the late 1920s, the Radio Corporation of America (RCA) purchased the Victor company for an estimated $154 million.

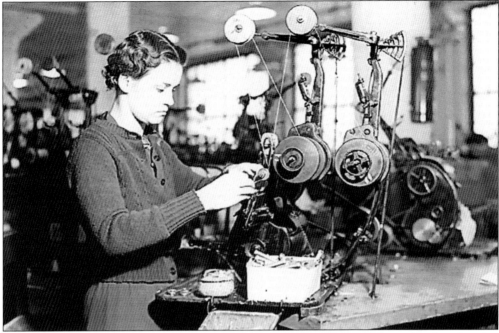

A young girl employed by RCA Victor as a coil winder concentrates on the task at hand in this 1937 photograph. Nimble fingers were a necessity for the young women hired as coil winders for the company's radio production line. (Courtesy National Archives and Records Administration, Special Media Archives Services Division.)

A cabinetmaker carefully assembles the front and ends (known as the waist) of a series of RCA radio cabinets as they roll along a conveyor belt in 1937. (Courtesy National Archives and Records Administration, Special Media Archives Services Division.)

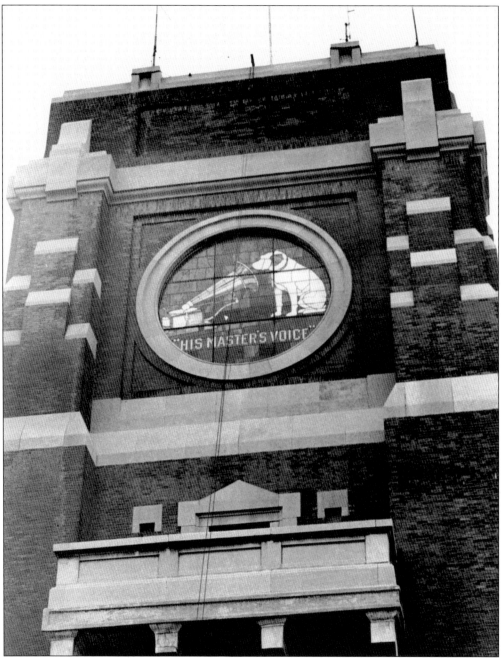

Nipper and the Gramophone, the trademark of the Victor Talking Machine Company, hold a place of honor above the doorway of the company's Camden headquarters. The image of the music-loving canine was created by English artist Francis Barraud, who captured his brother's dog Nipper's fascination with the horn of an early Edison phonograph in the winter of 1898. Barraud's title for the painting—His Master's Voice—became a part of the company's trademark as well, leaving only one obvious difference between the original painting and the RCA Victor trademark—the brand name on the pictured phonograph. (Courtesy Catholic Star Herald.)

In the forefront of television technology around 1931, RCA Victor engineer Randall Ballard tests a television camera based on Philo Farnsworth's image dissector technology (which remains the basis of all electronic televisions) by pointing it at engineer Les Flory. This and many other tests took place atop RCA's Building 5 in Camden. (Courtesy David Sarnoff Library.)

During World War II, RCA Victor (and many other Camden industries) turned its inventive skills toward military technology, obtaining top-secret contracts to develop radar, sonar, and proximity fuses. Here, an unidentified engineer assembles a camera using an iconoscope camera tube around 1943, as part of a military contract known as Project Block. Under the program, cameras were installed on war-weary bombers loaded with explosives and piloted remotely by television to attack Nazi submarine pens. (Courtesy David Sarnoff Library.)

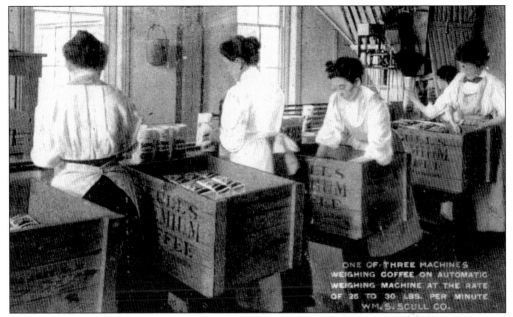

William S. Scull and Company was possibly Camden's earliest small industry employing immigrant laborers. Founded in 1831 by Joab Scull at Front and Federal Streets, the wholesale coffee operation included a large warehouse and coffee-roasting mill that employed 25 people by 1890. Later renamed the Boscul Coffee Company, manufacturing coffee, tea, and spices under its own label, the business closed in the 1970s.

The American Cigar Company factory was built in 1901 at Sixth and Mechanic Streets. Within a year, the factory employed 500 people. At the time, it was one of at least six cigar-manufacturing companies in Camden.

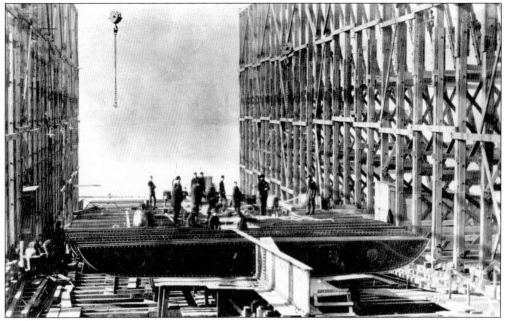

A construction crew lays the dolly keel at New York Shipbuilding on June 15, 1900, just a few months before the South Camden facility opened. Groundbreaking for the massive waterfront operation, which would construct the *Savannah*—the world's first nuclear-powered passenger cargo ship—as well as the battleships *Idaho*, *Saratoga*, and *South Dakota*, took place on July 3, 1899. The sprawling facility built ships for both world wars. (Courtesy Catholic Star Herald.)

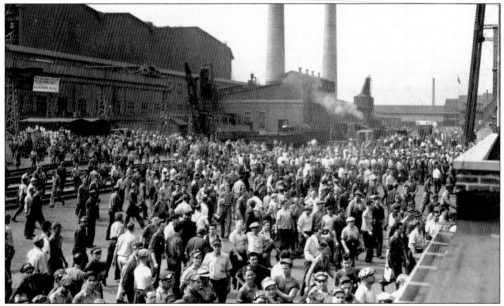

Dayshift workers approach the north yard clock sheds at the end of their shift in late 1947. Operating at peak production levels during World War II, New York Shipbuilding boasted approximately 33,000 employees on its payroll, including 3,000 female workers. Close to 17,000 workers staffed the dayshift alone, as the industrial giant raced to complete 25 major contracts. (Courtesy Catholic Star Herald.)

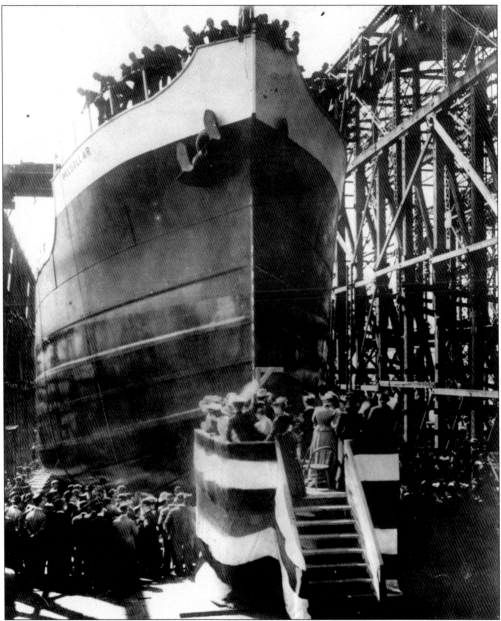

New York Shipbuilding's first contracted vessel was launched on May 4, 1901, in this public ceremony. Christened the M. S. *Dollar*, the ship was originally designed as a cargo vessel. It was later sold by the Dollar Company, converted into an oil tanker, and renamed the *J. M. Guffey*. New York Shipbuilding focused on constructing cargo ships and oil tankers until it received its first U.S. Navy contract in 1903, a break that turned the operation into a military manufacturing giant. (Courtesy Catholic Star Herald.)

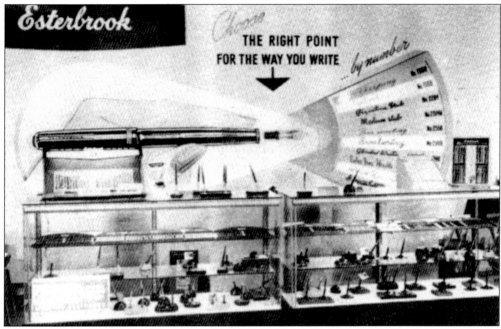

Esterbrook Steel Pen Company was established on Cooper Street in 1858. Eventually boasting 450 employees and producing 600,000 pens daily, Esterbrook was the first U.S. manufacturer of steel pen nibs, replacing hand-cut quill pens. In 1920, Esterbrook developed the fountain pen. Two of the nation's four pen factories called Camden home—Esterbrook and the C. Howard Hunt Pen Company, the first U.S. pen company, located at Seventh and State Streets. (Courtesy Camden County Historical Society.)

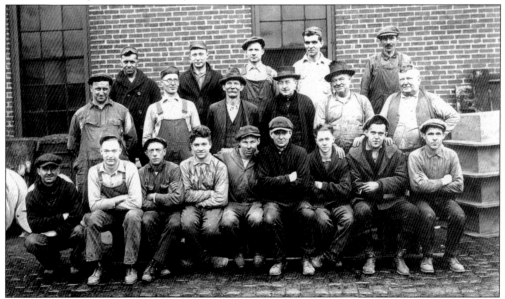

Camden foundry boys pose for a photograph at Johnson and Holt (the Pearl Street Iron Works), at the foot of Elm Street in 1892. The foundry was known for its gray iron castings and employed around 35 men toward the close of the 19th century. The site is now the location of Riverfront State Prison. (Courtesy Camden County Historical Society.)

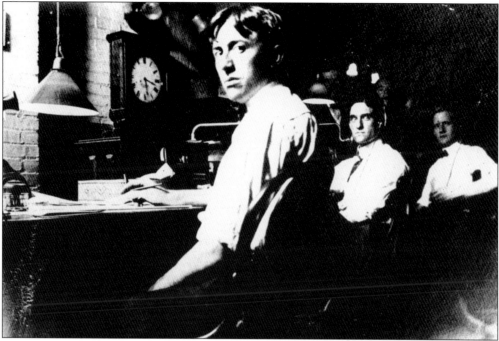

Male operators work the night shift in the basement of New Jersey Bell Telephone Company's two-story building at Fifth and Market Streets in the early part of the 20th century. (Courtesy Catholic Star Herald.)

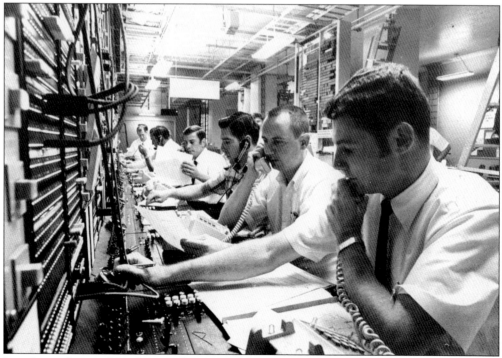

Long lines of men in New Jersey Bell's new Camden Communication Center, dedicated in October 1969, work around-the-clock shifts at the facility's test board. (Courtesy Catholic Star Herald.)

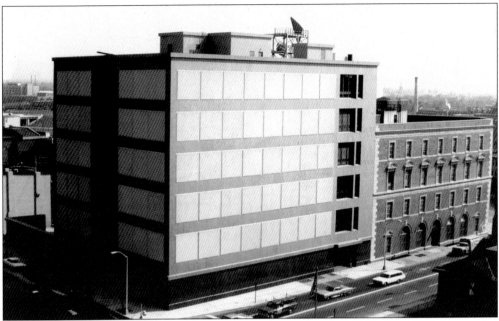

New Jersey Bell built this modern addition to its existing brick building in downtown Camden in 1969. The facility at Fifth and Market Streets housed an electronic translator, which was the brain of the telephone company's new computerized long-distance switching system. (Courtesy Catholic Star Herald.)

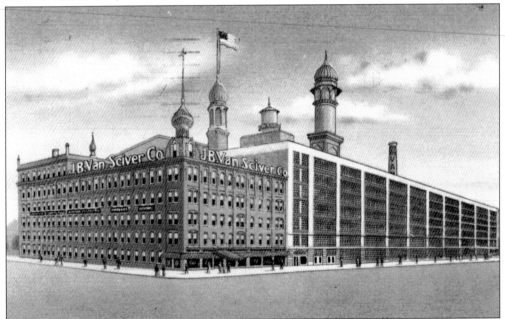

The Van Sciver Company began as a small furniture shop in 1881 and by 1928 was believed to be the largest plant in the country devoted exclusively to the manufacturing and sale of furniture. The company's 10-acre facility at Delaware Avenue and Federal Street was easily identified by its ornate spires and revolving light tower. The tower lamp was lit by 2,700 electric bulbs and reportedly was visible from 30 miles away.

The Security Trust Company, originally the New Jersey Safe Deposit and Trust Company, erected this commanding building at the corner of Third and Market Streets in 1886, providing financial services to the city until 1949. The third floor of the building was known as Lincoln Hall and was used for various lodge meetings.

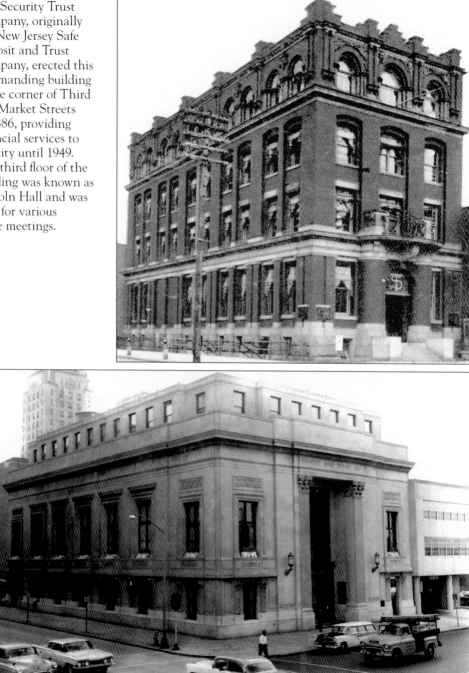

Between 1900 and 1929, Camden's annual industrial output skyrocketed from $20 million to $211 million, and business leaders dubbed it "the city of contented industries." With its wealth on the rise, Camden's financial institutions began growing as well. In 1927, the First Camden National Bank and Trust erected this massive building at the corner of Broadway and Cooper Street. The institution's roots trace back to 1812, when the city's first bank was incorporated. (Courtesy Gloucester County Historical Society.)

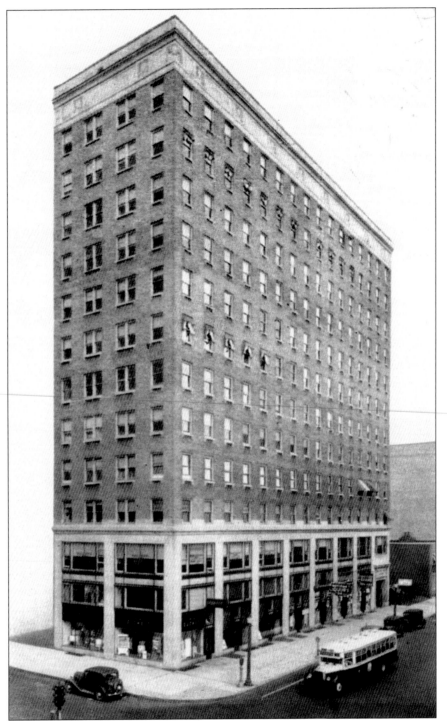

The 12-story West Jersey Trust Building, also known as the Wilson Building, was the city's first downtown skyscraper. Opened on November 23, 1926, the office building was erected by John O. Wilson and Joseph Bernhard at Broadway and Cooper Street for approximately $1 million. Among the longtime fixtures of the building was Weitzman Liquors on the first floor.

Four

IN THE BUSINESS

Founded in 1876, Bennett Lumber was New Jersey's largest retail lumber operation by 1900, encompassing two city blocks. The family-run business made local history in 1911 by adding a motorized truck to its stable of horse-drawn delivery wagons when a trucking company provided it in lieu of cash. In 1924, Bennett made history again by adding a sales office made of cinder blocks to the waterfront property, making it possibly the first in the world to use such construction. (Courtesy Bennett Lumber Company.)

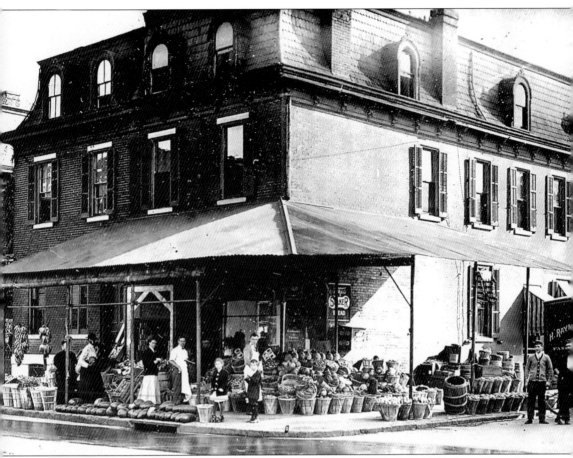

Raymond Staley's Grocery was located at Sixth and Penn Streets and billed itself as a "fancy grocer." Shown here in 1904, Staley's was one of more than 350 small neighborhood grocers in Camden at the time, stocking a selection of produce, pantry staples, and a small assortment of specialty items geared toward the ethnic makeup of the neighborhood.

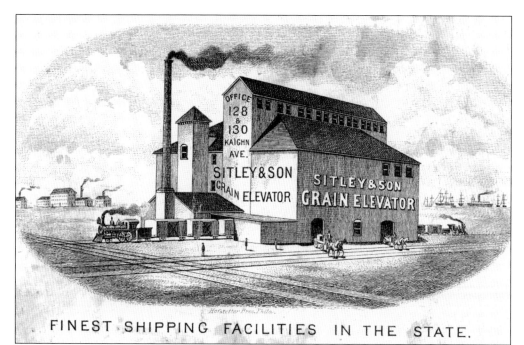

FINEST SHIPPING FACILITIES IN THE STATE.

Located at 128 Kaighn Avenue, in what later became downtown Camden, Sitley and Son was founded in 1879. The business specialized in oats but distributed a variety of grains, flour, seeds, and fertilizers and used two horse teams to make deliveries through the area. The grain elevator and office were destroyed by fire on February 11, 1920.

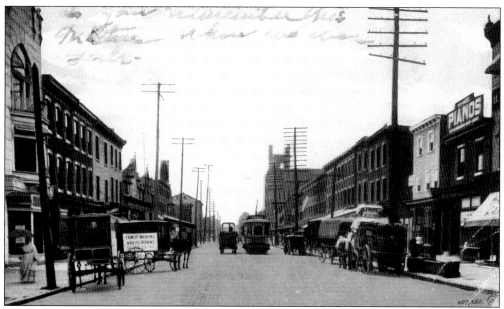

Small shops lined Camden's downtown streets around 1900, catering to the varied needs of the city's diverse population. Pictured here along Market Street looking west are some typical nondescript storefronts of the day. A laundry delivery cart marked "Family washing and ironing" stands parked in front of a flower shop at left.

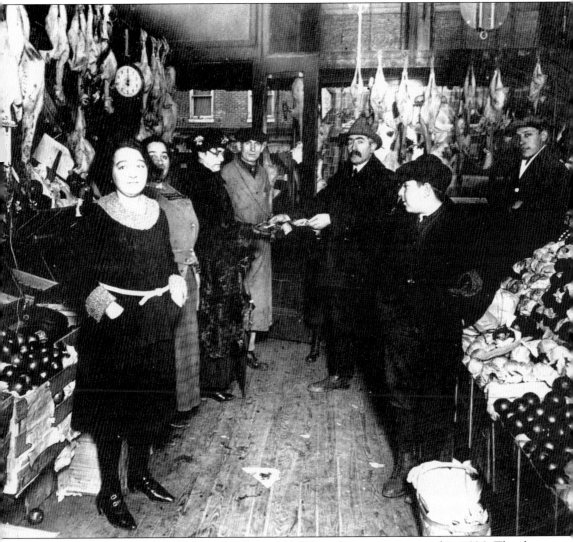

Pictured is Samuel Asbell's Fruit Market, at 1146 Broadway, as it appeared in 1926. The shop stocked a wide selection of fresh fruits, vegetables, and other assorted perishable goods, such as the geese displayed in this photograph. The owner is seen here (center) with a mustache and hat. (Courtesy Tri-County Jewish Historical Society.)

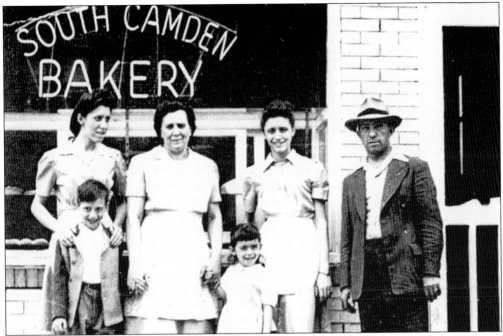

Nestled amid Italian households and social organizations and located at Fourth and Division Streets, Rosario Anselmo's South Camden Bakery was one of many Italian establishments in the area. The most well-known landmark on the block was the home and funeral parlor of Antonio Mecca, known as the White House. Mecca was so popular among Camden Italians in the 1920s and 1930s that many inaccurately answered the question "Who lives in the White House" when taking their citizenship tests. (Courtesy Camden County Historical Society.)

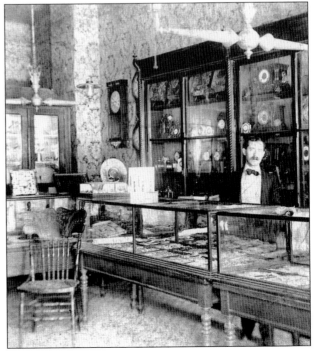

Harry Nurock opened his watchmaking store at 1124 Broadway in 1903 and operated at the prime business location until the 1930s. His gas-lit showroom was one of 16 watchmaking shops peppering the downtown area, including competitors on Kaighn Avenue, Federal Street, and Market Street. (Courtesy Tri-County Jewish Historical Society.)

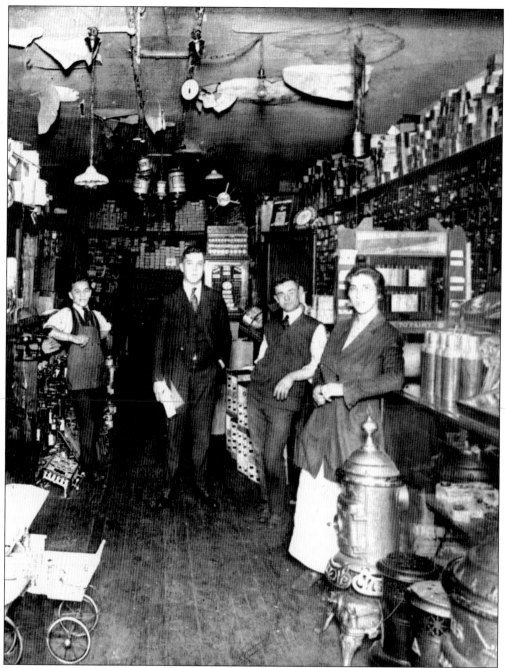

Owners of the Seidman Hardware Store meet with a traveling salesman (second from left) around 1925, as store clerk Henry Schreibstein (far left) looks on. The store stocked everything from baby buggies and bicycles to the latest-style coal heaters. (Courtesy Tri-County Jewish Historical Society.)

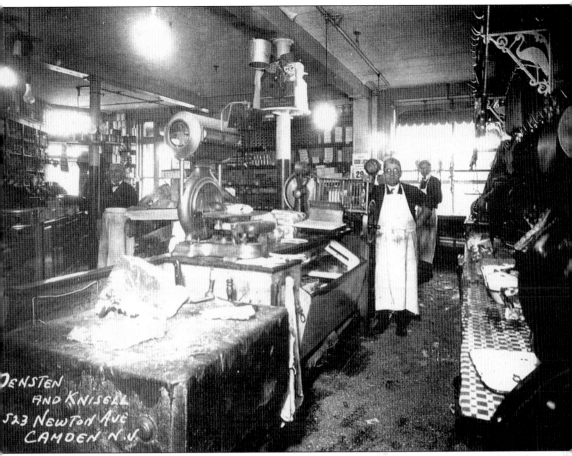

The New Market at 523 Newton Avenue operated from around 1916 to 1940, providing the South Camden neighborhood with fresh meats and a variety of food products. Pictured at work around 1930 are proprietors Warren T. Redfield (left), Wilberforce Densten, and Harry C. Knisell. (Courtesy Barbara Turner.)

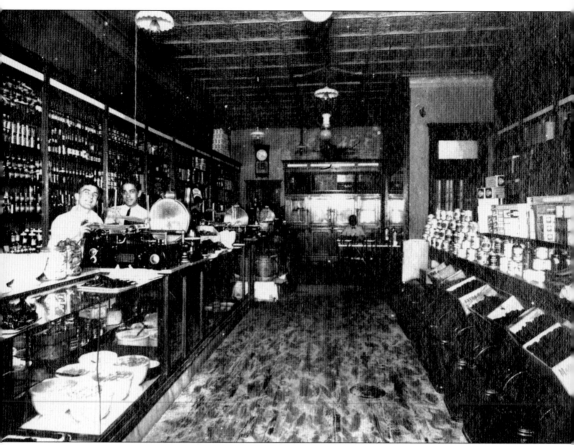

Lipsitz Deli, located at 454 Kaighn Avenue, is pictured here in 1920. A selection of homemade salads can be seen in the display case on the left, and crates of prunes are visible on the right. (Courtesy Tri-County Jewish Historical Society.)

The Stag Café was owned and operated by Timothy Donovan from the early 1900s through 1939. Located at 318 Market Street, in the middle of a block of prominent lawyers, the Stag Café later became the Majestic Restaurant.

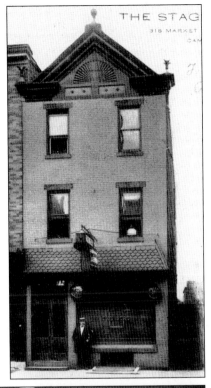

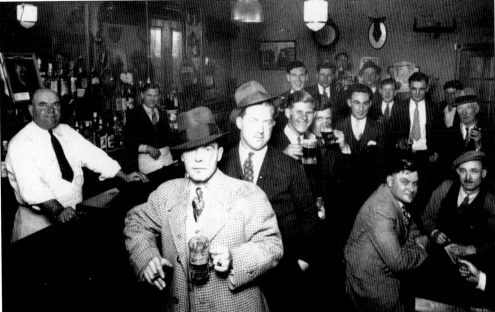

Walt Evanuk, owner of Walt's Café on Jasper Street, serves his regular patrons in this 1938 photograph, just a few years after the repeal of Prohibition. When Camden proprietors learned the alcohol prohibition had been lifted, the city was inundated with liquor license requests. On December 7, 1933, two days after the legislative change, Camden authorized a total of 197 establishments to sell liquor. (Courtesy Joe Paprzycki.)

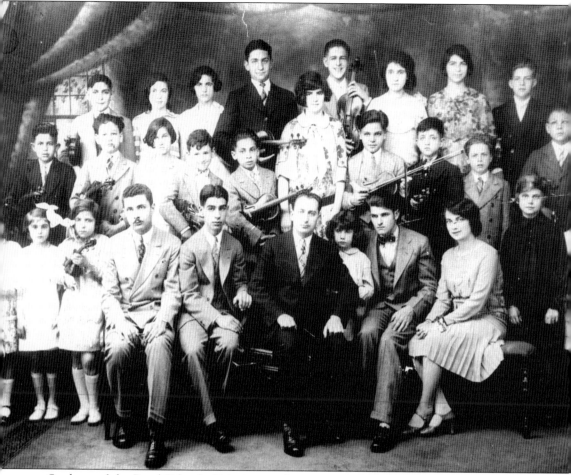

Students of the Berul School of Music pose for a portrait around 1924, the year Albert Berul launched his business in his home at 1395 Kenwood Avenue. In a 1936 advertisement, Berul boasted an "efficient faculty," providing quality musical training for all ages. A few years later, his continued success led him to add to his business interests by opening a store at 1206 Haddon Avenue, where he sold electric appliances. (Courtesy Tri-County Jewish Historical Society.)

Founded in 1931, during the height of the Depression, Shapiro's Corrective Shoes was the place to go for footwear for more than 30 years. Owners Harry and Roslyn Shapiro and their ethnically diverse sales staff worked closely with area hospitals and podiatrists, drawing clientele from the city and the suburbs to the store at 219 Broadway. The foot-sizing x-ray machine, which allowed customers to actually see the bones of their feet, was a high point of the experience.

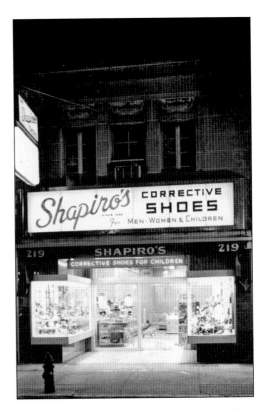

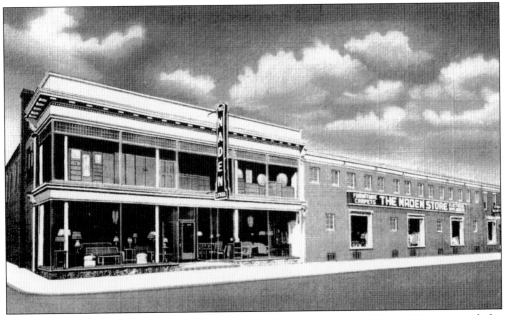

Naden's operated two stores in the city—one at Twenty-fourth and Federal Streets and the other, pictured here, at Kaighn Avenue and Eighth Street. Both specialized in furniture, home furnishings, toys, and gifts. The Federal Street store was sold to the Hurley department store chain in the late 1940s, while the Kaighn Avenue location remained in operation until 1977.

Established in 1941, Gaudio Brothers specialized in wholesale fresh fruits and vegetables at its Ninth Street and Fairview Avenue store. By 1948, the business was running a full-scale frozen food operation at Second Street and Kaighn Avenue, employing 57 to 100 people around the clock. With its fleet of refrigerated trucks, Gaudio's distributed Birds Eye, Pictsweet, and Delaney frozen foods to stores throughout the Greater Philadelphia area. (Courtesy Ralph Gaudio.)

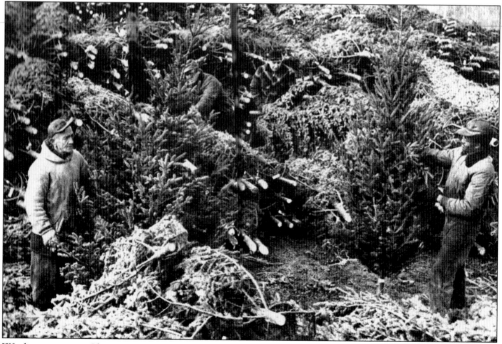

Workers prepare Christmas trees at Gaudio's tree yard on Broadway in 1957. Opening in 1955 on Mount Ephraim Avenue, Gaudio's Garden and Christmas Center was transformed into the Christmas Wonderland for the holidays. Crowds lined up to visit with Santa, listen to holiday music, peruse the beautifully decorated trees, and enjoy a free candy cane. (Courtesy Ralph Gaudio.)

Five

CITY STREETS

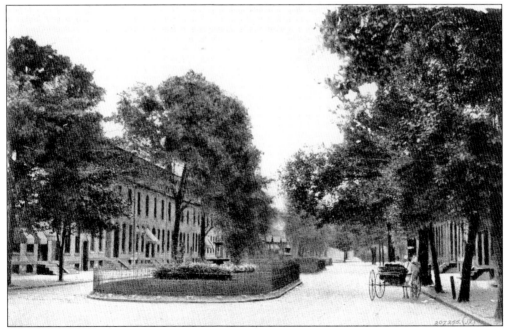

The Linden Terrace neighborhood, built between Fourth and Fifth Streets on Linden Street in 1870, was a peaceful enclave of 34 green stone houses along both sides of the tree-lined street. The neighborhood was razed in the mid-1920s to make way for the Delaware River (Benjamin Franklin) Bridge.

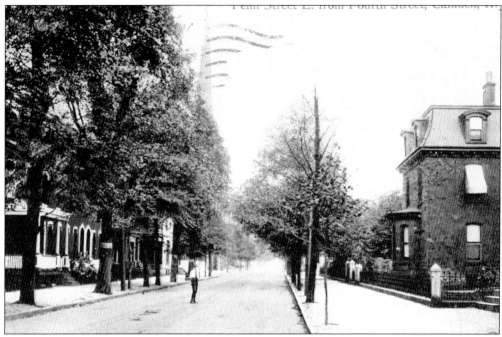

This portion of Penn Street, shown here as the view looking east from Fourth Street, was razed by Rutgers University in 1904. A quiet residential spot, it was home to several prominent citizens. On the right is the home of advertising executive W. Wayland Ayers, whose N. W. Ayers and Sons agency handled the country's first national advertising campaign and first radio commercial. On the left is the home and office of one of Camden's first female doctors, Sylvia Presley.

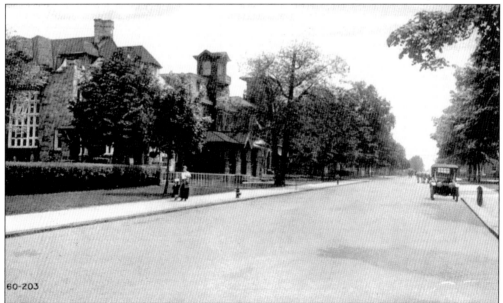

For many years one of the most prestigious addresses in the city, Cooper Street's wide residential setting made it the perfect location for horse-drawn sleigh racing on snowy winter days. Viewed here looking east from Sixth Street, are the homes of J. Lynn Truscott, president of the Camden Fire Insurance Association, and prominent attorney Howard M. Cooper.

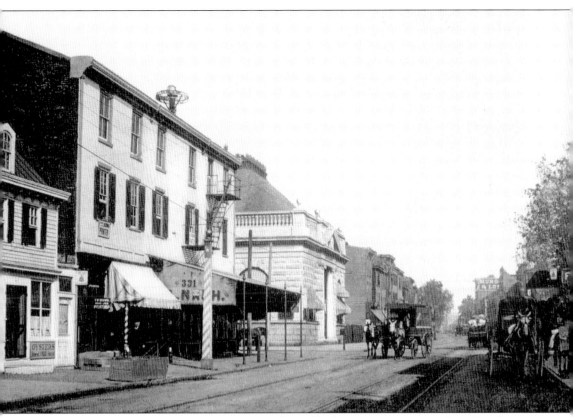

The 300 block of Federal Street, paved with Belgian block in 1880, was typical of Camden's downtown business district in 1906, when this photograph was taken. To the right behind the trees stands William French's liquor store, and in the distance the Munger and Long department store is visible. Along the left-hand side of the street stands the Davis Oyster House, Francis Brown's print shop, and the barber stations of Conrad Hoer and William Vissel. The stone building on the next block is the Central Trust Bank.

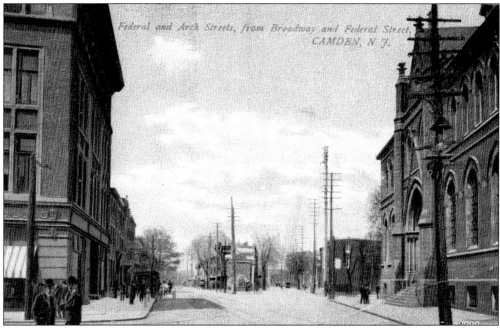

The Munger and Long department store (later J. C. Penney) stands at the left in this 1905 postcard of Federal and Arch Streets, while the courthouse can be seen at the right. At the Arch Street triangle (center) stands the Jessup Building, where George Jessup sold real estate insurance.

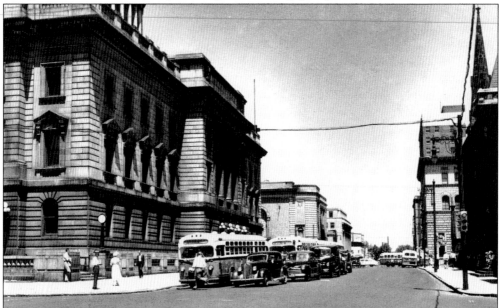

By the early 20th century, Camden's bustling business district spanned a five-mile stretch encompassing five streets—Market and Federal Streets, Kaighn and Haddon Avenues, and Broadway. This 1949 view of Broadway from Federal Street includes the old county courthouse on the left and Camden Safe Deposit and Trust Company on the right. In its heyday, the city's downtown streets were lined with modern shops, department stores, restaurants, theaters, banks, and offices. (Courtesy Haddonfield Public Library.)

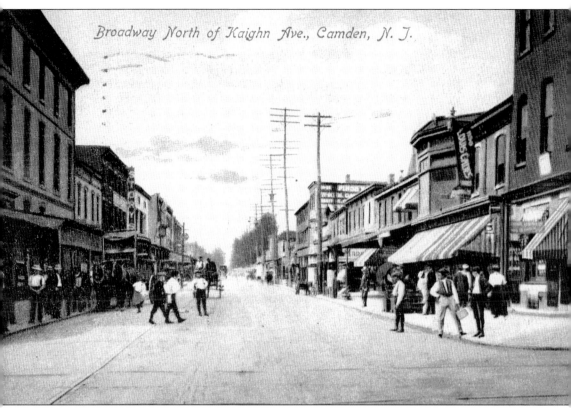

Toone and Hollingshed dry goods and notions store, which became A. G. McCrory's five-and-dime after World War I, stands on the left-hand corner of Broadway and Kaighn Avenue in this postcard dated from before 1906. Camden's busy business district blended eateries and shops early in the 20th century, including Story's (at left) and Pinsky's dry goods store (right). Broadway from Kaighn Avenue to Newton Creek was originally a wood-planked roadway that made a muddy mess out of anyone walking or riding along in wet weather.

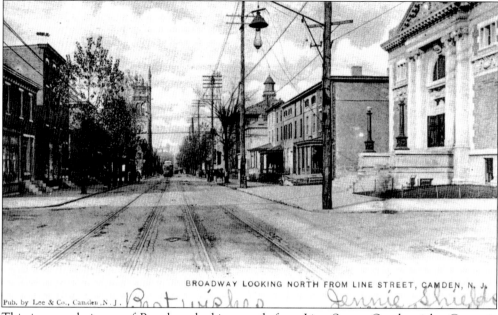

BROADWAY LOOKING NORTH FROM LINE STREET, CAMDEN, N. J.

Pub. by Lee & Co., Camden, N. J.

This is an early image of Broadway looking north from Line Street. On the right, Carnegie Library dominates the scene. Shops on the left-hand side include Barrett Brothers Drugs and Walk Over Shoes.

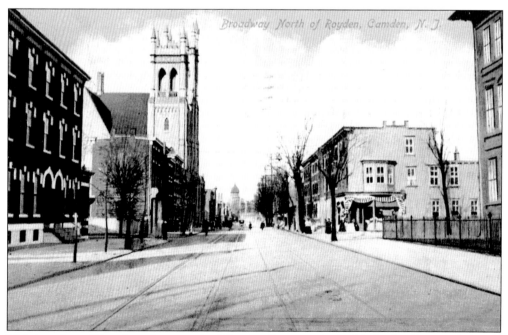

Broadway North of Royden, Camden, N. J.

This is a view of Broadway from north of Royden Street, with the Methodist Episcopal church dominating the scene.

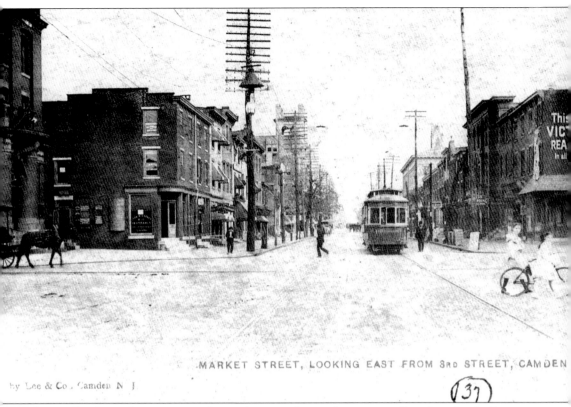

MARKET STREET, LOOKING EAST FROM 3RD STREET, CAMDEN

by Lee & Co . Camden N J

(37)

Originally planned to accommodate a heavy volume of wagon traffic when Jacob Cooper envisioned a market house here, this section of Market Street, looking east from Third Street, was designed with setback corners. The market house was never built, but the broad roadway remained. Showing part of the downtown business district, this postcard includes a real estate office on the left and the Stag Café in the middle of the block on the right-hand side.

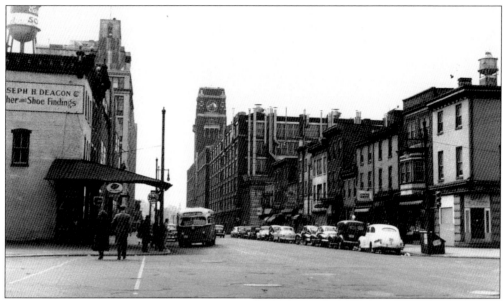

Two industrial powerhouses dominated Market Street near the waterfront—Campbell Soup Company, with its famous water tank, and RCA Victor, with its trademark Nipper-emblazoned tower. Both are pictured here in 1950. (Courtesy Haddonfield Public Library.)

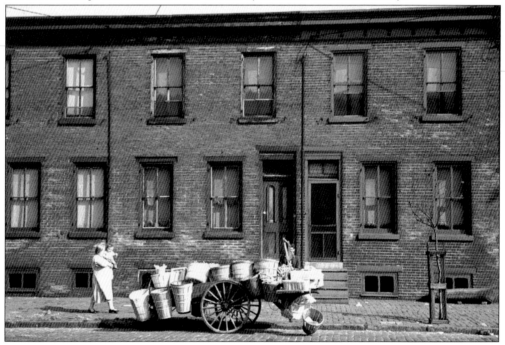

A street vendor's wagon stands in front of a row of unidentified factory workers' homes in 1938. Street vendors peddling everything from fruits and vegetables to housewares continued to serve some Camden neighborhoods into the 1960s. The wagons were originally powered by horse or the vendor himself; in later years these peddlers (also known as hucksters) traveled from neighborhood to neighborhood in open-back motorized trucks. (Library of Congress, Prints and Photographs Division.)

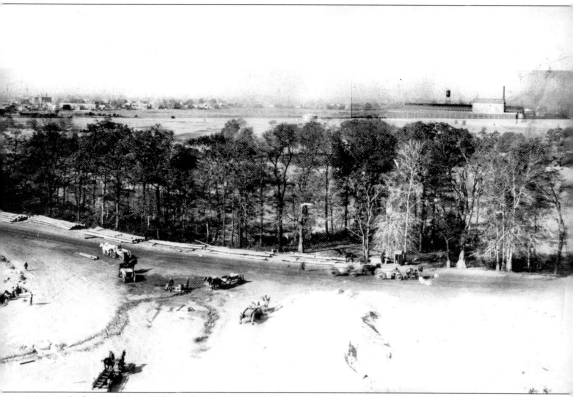

Materials for Yorkship Village (later renamed Fairview) are transported to the 225-acre site of the Old Cooper Farmstead by horse and wagon in October 1918. Located just upstream from New York Shipbuilding, on the south branch of Newton Creek, the development was one of 55 built by the federal government nationwide. The project was designed to house the influx of shipyard workers during World War I and was originally part of Haddon Township. (Courtesy Fairview Historic Society.)

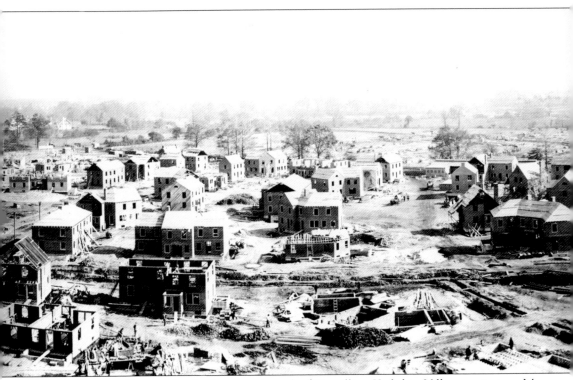

U.S. Housing Corporation broke ground on the $11 million Yorkship Village project on May 1, 1918. While the federal government covered construction costs, local government was saddled with the expense of installing utilities and providing police and fire protection. The financial burden quickly proved to be too much for Haddon Township, which gladly turned the neighborhood over to Camden. Originally rented to shipyard workers, the homes were sold to laborers in a three-day auction in 1921, with 1,500 properties selling for between $800 and $1,800 each. (Courtesy Fairview Historic Society.)

Six

SERVING THE PUBLIC

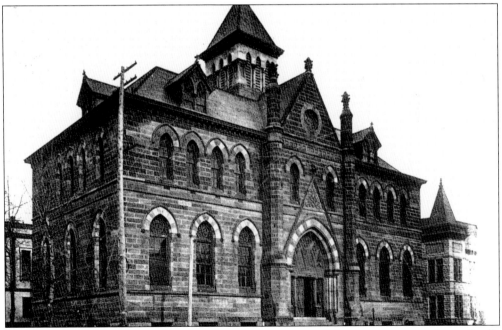

The battle over designating Camden the county seat raged for seven years and was finally resolved in 1851 by the New Jersey Supreme Court. This two-story brick building was originally erected as the county jail in 1855 but was redesigned as the county's first courthouse. Situated on the south side of Federal Street, between Fourth and Fifth Streets, it was later returned to use as a jail, with an iron cage to hold convicted murderers.

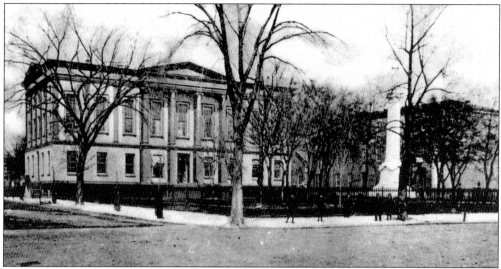

This early building, constructed shortly after the first county courthouse on adjoining grounds, assumed the role of county courthouse, making it the second building used as a Camden County court facility.

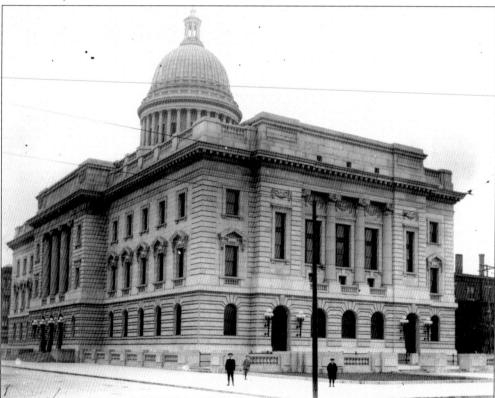

Camden County's third designated courthouse held a commanding view of the downtown area. Built for $800,000 in 1906 at Broadway and Market Streets, the massive masonry building boasted a towering dome reminiscent of the Capitol in Washington D.C. and a winding marble staircase. (Courtesy Cooper University Hospital Archives.)

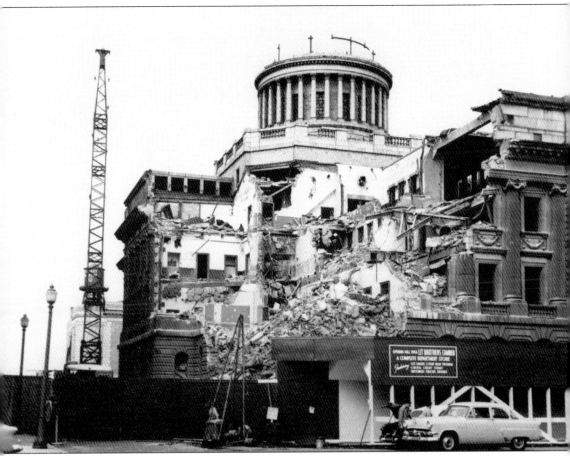

The county courthouse came tumbling down in March 1954 to make way for the sprawling Lit Brothers department store. Lit Brothers purchased the Broadway and Federal Street property for $500,000 and opened for business in 1955, proclaiming it was "proud as a peacock to come to Camden." Seventeen years after its grand opening, Lits closed its doors in Camden. (Courtesy Haddonfield Public Library.)

Camden's first city hall was erected in 1828, the year the city was incorporated, although in the early days the city council preferred to meet in local taverns. The lower floor of the building was used as the city jail, while the upper level, accessed by an outside wooden staircase on Federal Street, was reserved for council meetings and court sessions.

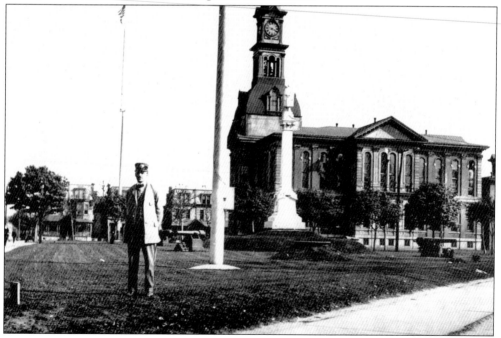

In 1875, Camden's second city hall was constructed at Haddon Avenue, between Benson and Washington Streets. The building cost the city $140,000 to erect. The distinctive clock tower alone, which first sounded on May 26, 1876, cost $3,575.

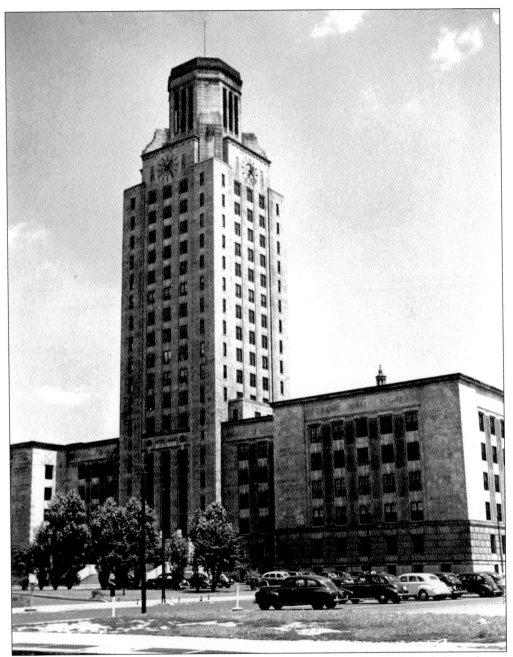

This towering structure at Fifth and Federal Streets permanently changed the skyline when it was completed in 1930, replacing Camden's 1875 city hall with over 22 stories of architectural magnificence. But when the Depression hit hard, the city seriously considered putting its brand new building up for sale. (Courtesy Haddonfield Public Library.)

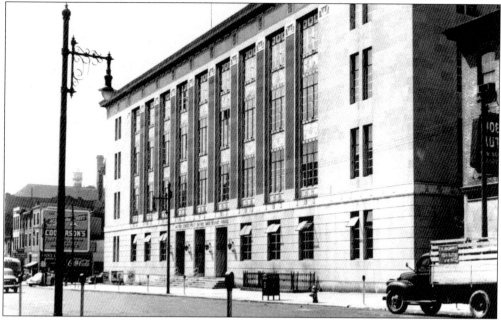

Camden's post office and federal courthouse building was constructed on the site of the old Temple Bar and Hotel and Temple Theater at Market and Fourth Streets. Emma Hyland became the first woman to hold the postmaster job when Pres. Franklin Roosevelt appointed her to the Camden facility in 1934. The city's first post office was established in 1803 and was housed in a hotel at the foot of Cooper Street. (Courtesy Haddonfield Public Library.)

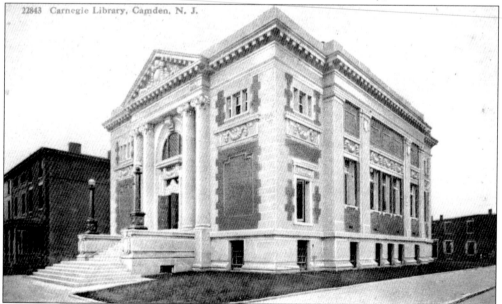

The two-story Camden Free Public Library at Broadway and Line Street opened on June 27, 1905, with 7,000 books on the shelves. Construction of the library, which was also known as Carnegie Library, was financed with $100,000 from Andrew Carnegie, but the steel magnate had to be tapped for an additional $20,000 to cover the cost of furnishings before the library could open.

The Cooper Branch Free Public Library, financed by Victor Talking Machine Company founder Eldridge Johnson, was South Jersey's foremost cultural center when it opened in Johnson Park along the waterfront in 1918. By 1927, it was one of four free public libraries in Camden, which also boasted four private libraries—the Camden Bar Association Law Library, the Catholic Lyceum Library, the North Baptist Church Library, and the Pyne Poynt Library. (Courtesy Haddonfield Public Library.)

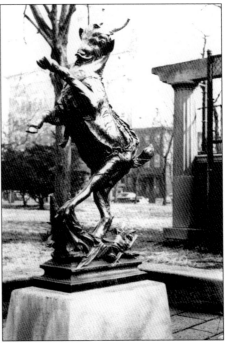

Nationally acclaimed sculptor Albert Laessle was commissioned to create several whimsical bronze animal statues for the grounds of Johnson Park. As a young artist, his sculptures were so realistic that fellow students accused him of casting them from life, a criticism the great French sculptor Rodin faced in his day. (Courtesy Haddonfield Public Library.)

73

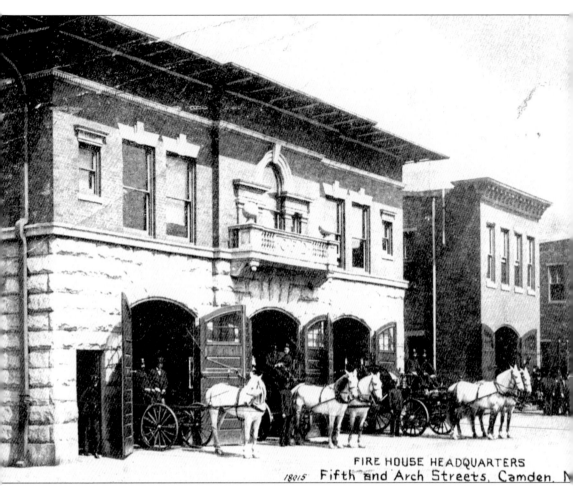

FIRE HOUSE HEADQUARTERS
1895 Fifth and Arch Streets, Camden, N

Engine Company 2 was one of the first Camden units established as a paid department. Located at Fifth and Arch Streets, the engine company was founded in 1869. The fire marshal earned $800 that year, while extra men on call for service received $50 annually. By 1927, Camden was one of the first cities in the country to boast a completely motorized fire department.

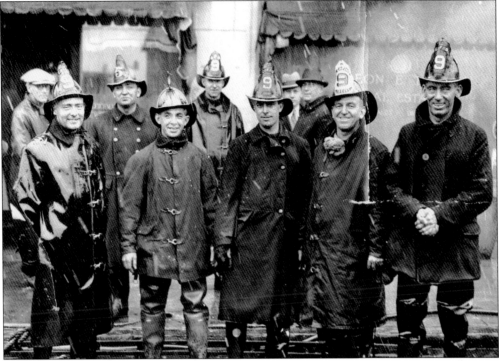

John Voll, Edward Peraria, Howard Gick, Capt. Ely Hunt and George Townsend, firefighters from Engine Company 9, based on Twenty-seventh Street, take a moment together following a fire on a rainy night in December 1928, seen here in the first row from left to right. The blaze involved the offices of Leon E. Todd at 2623 Westfield Avenue. Todd was a realtor who helped develop Medford Lakes. (Courtesy Patricia Peraria Villano.)

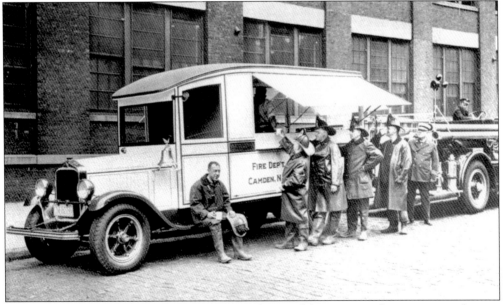

In the 1920s, the Camden Fire Department made use of this one-ton chassis converted into a canteen to serve firefighters at the scene. (Courtesy City of Camden.)

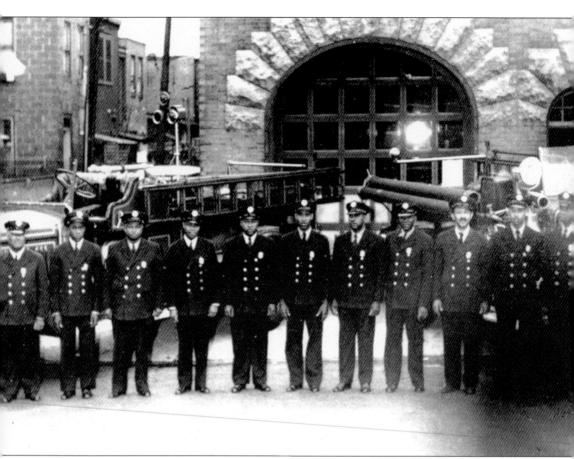

Engine Company 1, at Fourth and Pine Streets, was Camden's first black fire company. Pictured here around 1949, from left to right, are Alfred Greene, Fred Henderson, Charles Cook, Leroy Hatchett, Robert Thomas, Andrew Robinson, James Richardson, Eugene Alston, James Clinton, and Captains Jesse Jones and Raymond Amos. Amos was the first black Camden firefighter promoted to the rank of captain. (Courtesy City of Camden.)

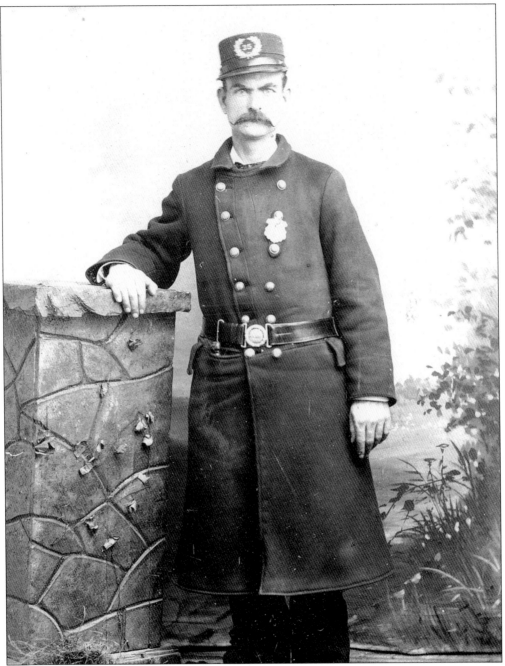

Joseph Blair, pictured here in full uniform in 1884, walked a beat in the Fourth Street and Kaighn Avenue area, using a whistle to signal wrongdoers to halt or summon help. Offenders he apprehended were transported to jail in a pushcart until the city ordered its first patrol wagon in 1892. The Camden Police first received uniforms in 1868. (Courtesy Camden County Historical Society.)

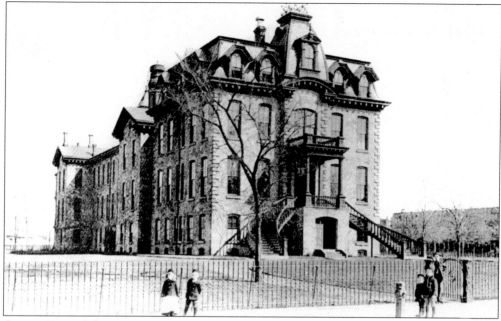

Cooper Hospital, boasting 30 beds, was constructed in 1877 with $95,000 from Dr. Richard M. Cooper and his family, to provide Camden's indigent population with free care. For a decade, its only beneficiary was the live-in caretaker, since there was not enough money to staff the facility. Ironically, once opened for business Cooper never again locked its front door. It seems the lock was temperamental and the key was eventually lost. (Courtesy Cooper University Hospital Archives.)

Once opened, the hospital quickly outgrew its quarters. In its first five years, 1,871 patients were admitted and 11,671 received outpatient care. Between 1903 and 1911, three construction projects were undertaken—nursing quarters, a medical ward for women, and an outpatient building. The Cooper complex is seen here from the Benson Street entrance in the early 1900s. The dapper gentleman with the collie is believed to be Dr. Charles H. Johnson. (Courtesy Cooper University Hospital Archives.)

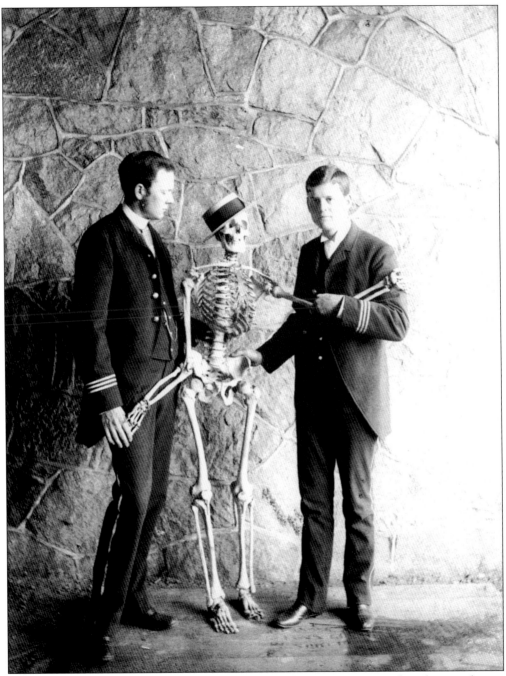

Dr. Burr MacFarland (left) and Dr. Harry Jarrett had reputations as good students and great pranksters while serving as Cooper Hospital's first residents. On this memorable afternoon in 1888, they borrowed a skeleton from a surgeon's office near the operating room for an impromptu outdoor examination. Pranks aside, both MacFarland and Jarrett were good practitioners. They were required to visit every patient twice a day, and the seriously ill more frequently. Provided with free board, they were precluded from accepting fees for their services. (Courtesy Cooper University Hospital Archives.)

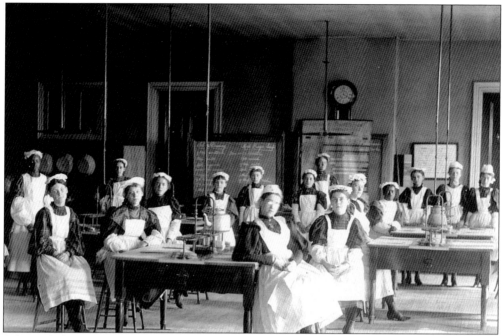

What is believed to be Cooper Hospital's early cooking and housecleaning staff poses for the camera in the kitchen. A variety of nutritional information fills the chalkboards at the back of the room. (Courtesy Cooper University Hospital Archives.)

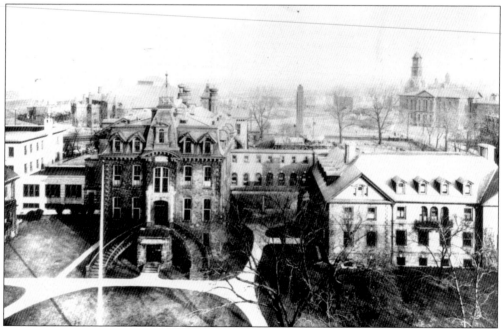

An aerial view of Cooper Hospital and the surrounding area, around 1929, shows the continued growth of the facility. In the upper right-hand corner, behind the 1911 outpatient building, is Camden's second city hall, with its easily identifiable clock tower. (Courtesy Cooper University Hospital Archives.)

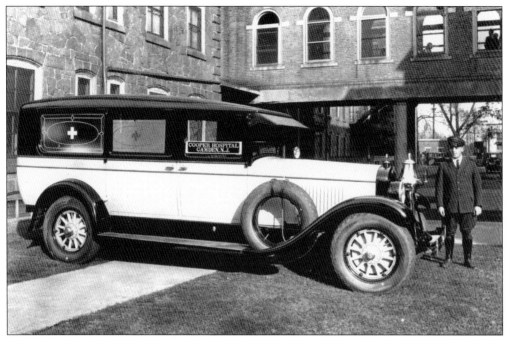

In 1926, hospital patients began arriving in style when an anonymous donor gave Cooper Hospital its first motorized ambulance. The white and black Leland Lincoln was manned by Louis Pear, shown here in full uniform. The ambulance was used regularly to transport patients to the hospital from their homes or the train station. (Courtesy Cooper University Hospital Archives.)

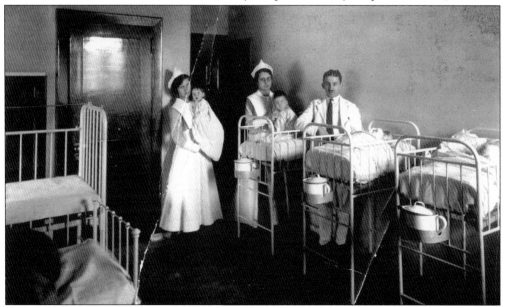

Pediatrician Vincent Del Duca strikes a rare pose while wearing a lab coat in Cooper Hospital's nursery in 1926. Del Duca was well known for refusing to wear a lab coat and advising the parents of sick children to feed them a ripe banana. Years later he explained his reasoning as follows: "they were good and children suffering from malnutrition thrived on them." (Courtesy Cooper University Hospital Archives.)

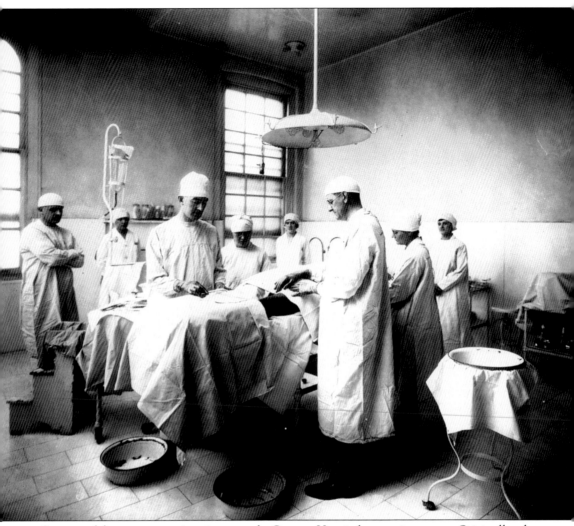

Surgeons labor over a patient in an early Cooper Hospital operating room. Originally, the hospital provided free medical treatment to the community and accepted contributions from patients who could afford to pay. In 1919, the board of directors voted to require that anyone able to pay be charged for services. The average daily fee was $3.52. Since Cooper was established for the poor, and wealthy residents who suffered from illnesses were treated at home by their personal physicians, there was no need for luxuries in the hospital's wards. Each patient was assigned a single iron bed and a straight-back chair, and beds were placed a mere arm's length apart. (Courtesy Cooper University Hospital Archives.)

The Camden Municipal Hospital for Contagious Diseases opened in permanent quarters on Sheridan Street in 1916 and treated over 100 polio patients that year. As early as 1910, smallpox patients were treated in isolation huts on the 15-acre site. These huts later served as the nurses' home and housed chickens, sheep, and other animals that supplied the hospital with food. Originally, the hospital had no staff; instead, family physicians visited patients. (Courtesy Catholic Star Herald.)

A young patient's doll awaits her return at the Camden Municipal Hospital in the early 1960s, just a few years before the facility closed. Over the years, the hospital primarily treated patients with diphtheria, scarlet fever, whooping cough, meningitis, measles, chicken pox, venereal diseases, and typhoid fever. (Courtesy Catholic Star Herald.)

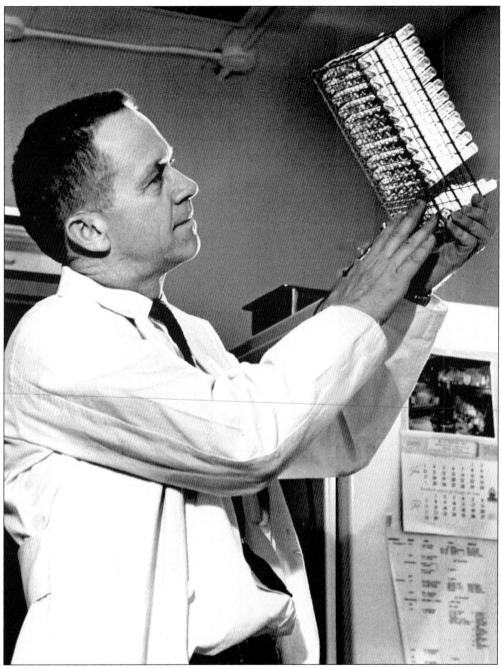

While serving as Camden Municipal Hospital's director in the early 1950s, Dr. Lewis L. Coriell conducted research on polio victims at the facility and determined that a vaccine could be developed to fight the virus. He later conducted field trials for the Salk vaccine at the hospital. Coriell, seen here inspecting test tube samples, founded the Coriell Institute for Medical Research in Camden in 1953. It has since become the world's largest repository for living cells for research. (Courtesy Coriell Institute for Medical Research.)

The catalysis behind the establishment of Our Lady of Lourdes Hospital at the corner of Haddon and Vesper Avenues, Bishop Bartholomew Eustace removes the ceremonial first shovel of dirt from the hospital construction site on September 8, 1947. Camden's first bishop saw a need for the hospital when he learned there was no Catholic medical facility between Trenton and Cape May, a distance of 139 miles. (Courtesy Lourdes Health System.)

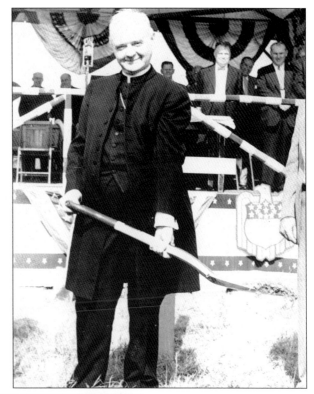

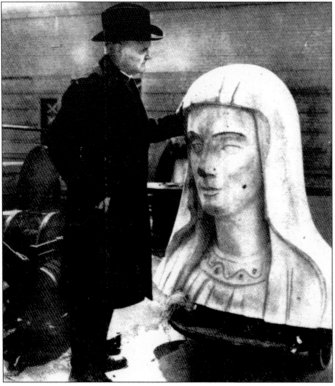

Bishop Eustace poses with the head of the 15-ton, 22-foot-tall Blessed Mother statue that tops Lourdes. The largest statue in the country at the time, as it was being erected in six sections, the head nearly plunged seven stories, leading the hospital administrator to write a note asking the Blessed Mother to bless Camden and the hospital, and the bishop to acquire a relic of St. Francis. Both remain inside the head today. (Courtesy Lourdes Health System.)

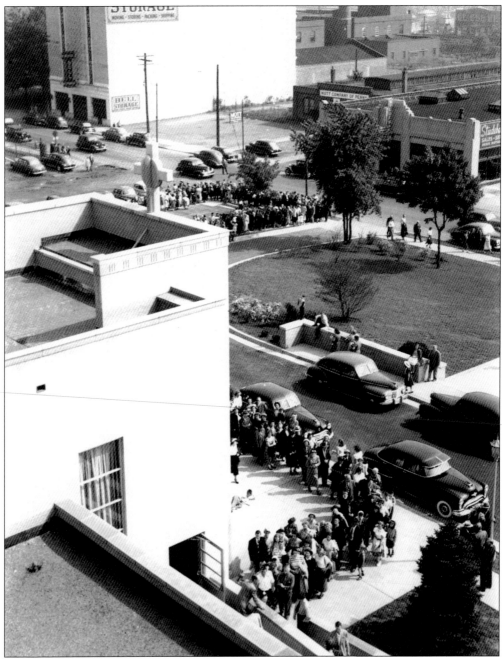

Constructed for $3.94 million, Our Lady of Lourdes Hospital was financed and operated by the Franciscan Sisters of Alleghany, New York, and treated its first overnight patient, a burn victim, on July 1, 1950. Anxious for a glimpse of the city's newest addition to the medical community, thousands of residents from Camden and the neighboring suburbs lined up in their Sunday best to tour the hospital on opening day, May 28, 1950. The facility was open for public inspection for three days, and in a single day an estimated 2,000 people toured the new medical facility, some waiting in line for over two hours before reaching the entranceway. (Courtesy Haddonfield Public Library.)

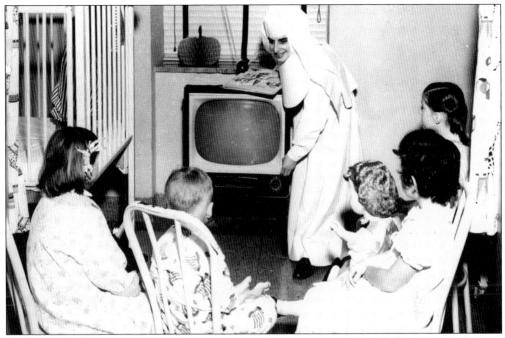

Committed to keeping patrons (even young ones) content, one of Our Lady of Lourdes' sisters adjusts the black and white television in the children's ward at the hospital, around 1958. (Courtesy Lourdes Health System.)

The Floating Church of the Redeemer originally rested on two 100-ton barges in Philadelphia's harbor, serving seamen in the name of Philadelphia's Churchmen's Missionary Association. In 1852, it was renamed St. John's Episcopal Church and moved ashore in Camden to the corner of Broadway and Royden Street. The building was destroyed by fire on Christmas Day 1870, and a new church was constructed the following year. (Courtesy Catholic Star Herald.)

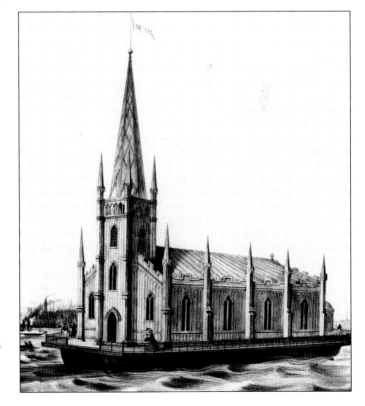

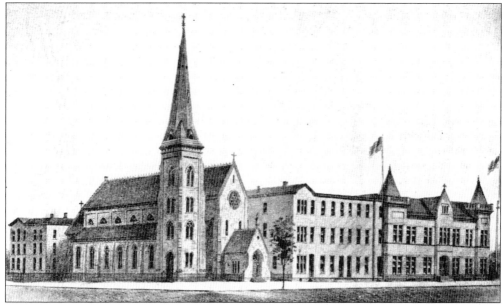

The Cathedral of the Immaculate Conception, dedicated in 1866, was built under the guidance of Fr. Patrick Byrne at Broadway and Market Street, marking the end of violence against the city's Catholic population, which had been prompted by the influx of Irish immigrants in the 1830s. In 1852, the anti-Catholic campaign led to the partial burning of Starr's Hall, where mass regularly was held.

The installation of Bartholomew Joseph Eustace as the first bishop of Camden took place before a standing-room-only crowd of parishioners and church leaders at the Cathedral of the Immaculate Conception on May 4, 1938. A crowd of close to 5,000 gathered in the streets surrounding the cathedral and listened to the ceremony by loudspeaker. (Courtesy Catholic Star Herald.)

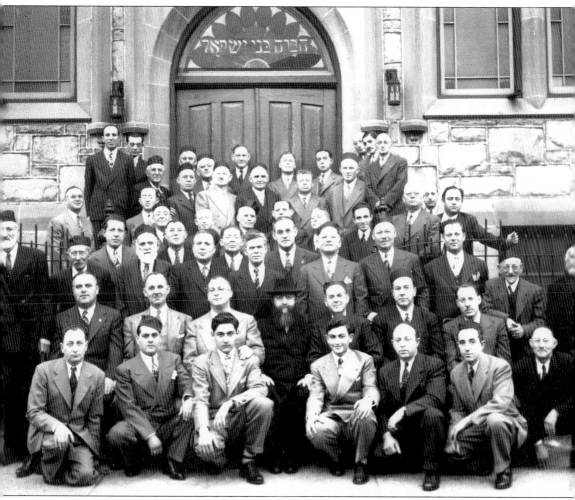

Members of Rabbi Naftali Riff's 1944 bible class, known as the Eighth Street Schul, pose in front of Congregation Sons of Israel at Eighth and Sycamore Streets. Rabbi Riff led the orthodox synagogue, one of four in the city, from the early 1920s through the late 1960s. The Rabbi Naftali Riff Yeshiva in South Bend, Indiana, which operates as a high school and rabbinical college, was named after the Camden spiritual leader. Congregation Sons of Israel was founded in 1886 and moved to Cherry Hill in the late 1960s. (Courtesy Tri-County Jewish Historical Society.)

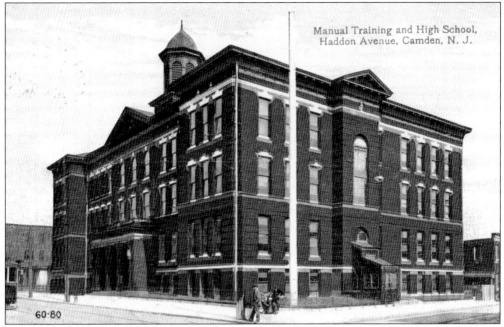

Manual Training and High School,
Haddon Avenue, Camden, N. J.

After outgrowing the upper floors of a Federal Street building that could accommodate 150 students, the city built its first high school in 1899. The Camden High and Manual Training School, at Haddon and Newton Avenues, could accommodate 500 students, who spent four years receiving either an academic, basic, technical, or classical education. By 1916, the student population had swelled to 700, and a new high school was under construction, capable of accommodating 1,500 students.

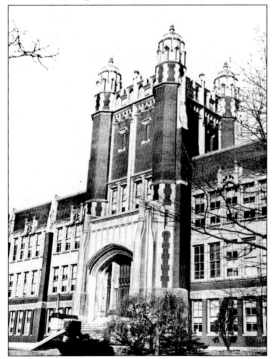

Camden High School holds a commanding view over Park and Baird Boulevards. Dedicated on April 25, 1918, the new school cost $500,000 and was constructed on what was once part of Forest Hill Park (later renamed Farnham Park). In the early 1930s, the city erected a second facility—Woodrow Wilson High School—on Federal Street.

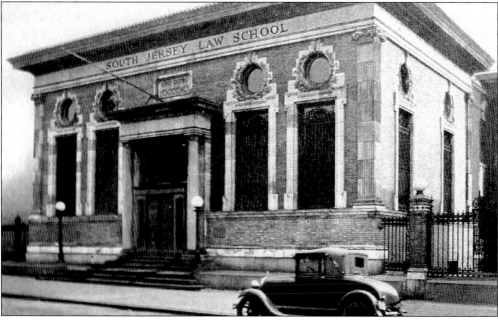

South Jersey Law School was founded in 1926 by Collingswood businessman Arthur Armitage Sr. and a group of business leaders who felt the South Jersey area needed a law school. A year later, when national admissions regulations changed and students could no longer enter law school directly after high school, the College of South Jersey was founded. Together they were incorporated as Rutgers University-Camden in 1952. (Courtesy Rutgers University-Camden.)

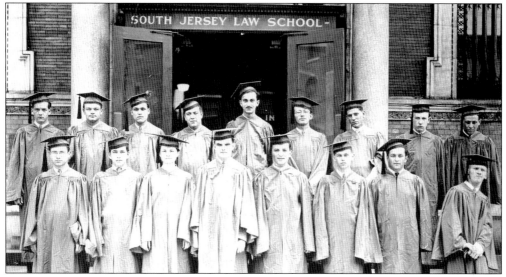

The College of South Jersey class of 1931 poses in front of the campus headquarters building at 224 Federal Street. Most of these graduates went on to attend South Jersey Law School (later renamed Rutgers School of Law). Pictured from left to right are (first row) Roland C. Nowrey, unidentified, Emma M. Thegan, Robert M. Landis, unidentified, Alex Sheunemann, Louis Francisco, and Joseph Lodge; (second row) Fred L. Streng, Edward Arndt, unidentified, Elmer Bertman, Jack Kellmer, Daniel Rosenberg, Ralph K. Turp, Martin F. McKernan, and unidentified. (Courtesy Rutger's University-Camden.)

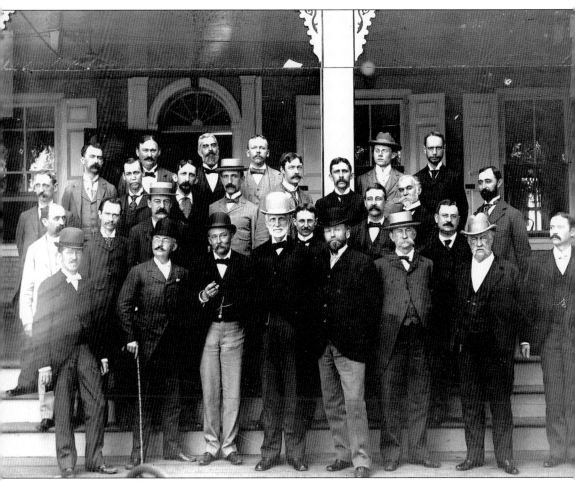

Members of the Camden County Bar Association, founded in 1881 for attorneys practicing in Camden, pose for a photograph during their annual shad dinner, around 1894. Pictured from left to right are (first row) district court judge Charles Joline, supreme court judge Charles Garrison, circuit court judge Richard R. Miller, vice chancellor Henry C. Pitney, supreme court judge Alfred Reed, Benjamin Shreeve, Caleb Shreeve, and George H. Pierce; (second row) William Casselman, Edwin Bleakly, J. Willard Morgan, Peter Voorhees, Samuel Beldon, Frank Shreeve, Scuyler Woodhull, Lewis Starr, H. S. Scovel, George Vroom, Charles Wooster, and Howard Carrow; (third row) Samuel Robbins, E. A. Armstrong, Thomas Curley, unknown Philadelphia Bar Association member, Charles Stevenson, H. F. Nixon, Henry I. Budd, and Israel Roberts. (Courtesy Gloucester County Historical Society.)

Seven

A SENSE OF COMMUNITY

Participants in Camden's first Veterans Day celebration parade down Broadway and Federal Street on November 11, 1954, cheered on by a sea of city and suburban residents. Prior to 1954, November 11 was known as Armistice Day, in honor of World War I veterans. (Courtesy Courier Post Library.)

By 1916, more than 200 religious, social, service, and political organizations existed in the city. The Camden Lodge of Elks dedicated this renovated home as its headquarters in 1910. Fifteen years later, lodge members broke ground on a new building at Cooper and Seventh Streets.

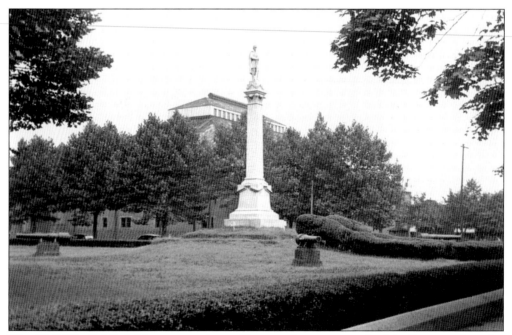

The Civil War Soldier's Monument, pictured here at the armory and originally erected on the grounds of the county courthouse in 1873, was commissioned to commemorate the city's soldiers lost in the war. During the national conflict, recruiters could be found on nearly every street corner, a cavalry unit was organized in the city, and boys between the ages of 10 and 18 drilled several times a week on Second Street. (Courtesy Haddonfield Public Library.)

Scene in Forest Hill Park, Camden, N. J.

Forest Hill Park, later renamed Farnham Park, was opened to the public in March 1905 and included several acres of athletic fields, as well as well-tended open space. The 80-acre park quickly became a favorite destination for a romantic stroll, a Sunday drive, a family picnic, or an afternoon gathering of friends and neighbors. Set along the Cooper River in Parkside, it was praised as "the largest breathing spot" in the city.

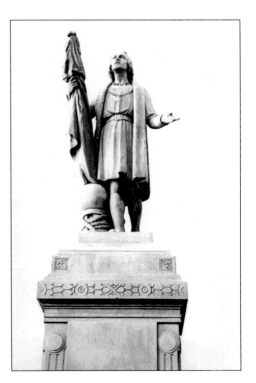

The statue of Christopher Columbus was erected in Forest Hill Park by the city's Italian-American community, which financed its purchase through private donations. It was unveiled during Camden's Columbus Day celebration on October 12, 1915, five years before the holiday became nationally recognized. (Courtesy Haddonfield Public Library.)

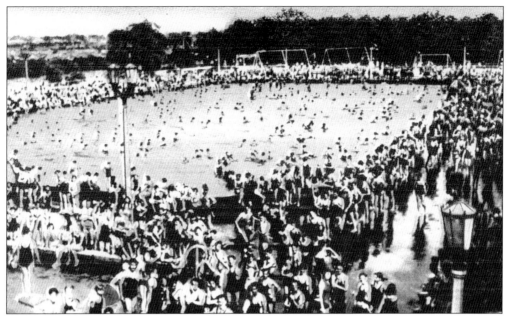

The swimming pool at Farnham Park was a gathering place for the city's youth on hot summer days. In 1924, Camden boasted 3 swimming centers, 5 wading pools, 4 recreation centers, and 12 playgrounds. A total of 1.2 million visits were recorded at these public facilities that year.

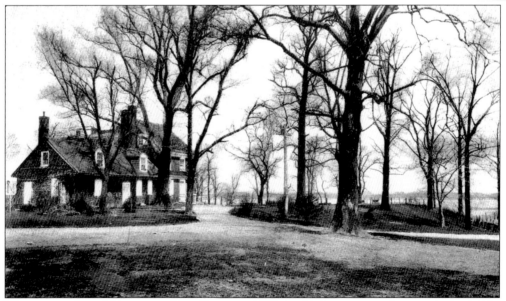

The city purchased 21 acres at Pyne Poynt in 1913, establishing a waterfront park shaded by poplars and buttonwoods for the community's benefit. Joseph Cooper's house served as the Pyne Poynt Library, with a cozy reading area for patrons to relax by the original 1683 fireplace. A $6,500 bandstand was added to the grounds in 1916.

Hundreds attended the dedication of internationally acclaimed sculptor George Frampton's Peter Pan statue during Camden's 1926 Children's Festival. Thrilling local children, Tinkerbell herself unveiled the bronze in Johnson Park. Statues also were designed and erected in Brussels, Newfoundland, and London. Peter Pan author J. M. Barrie personally had the London statue delivered to the exact spot where the fictional Peter landed in Kensington Park. (Courtesy Haddonfield Public Library.)

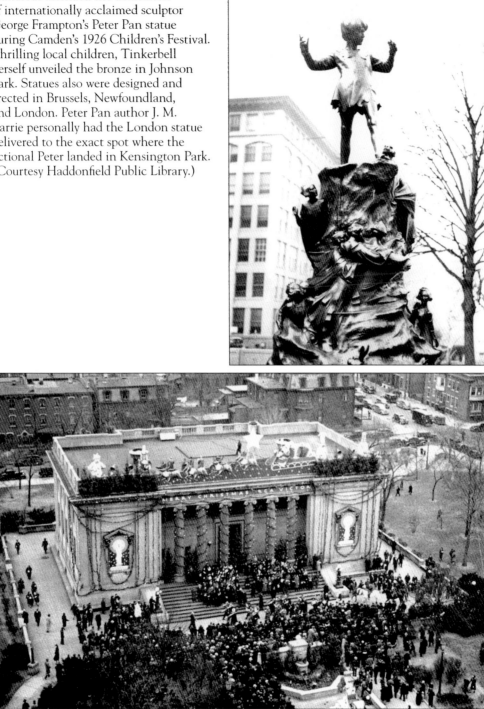

The annual Christmas celebration at the Cooper Branch Free Public Library always drew a crowd, like the one enjoying carolers and a local marching band here in 1939. (Courtesy Haddonfield Public Library.)

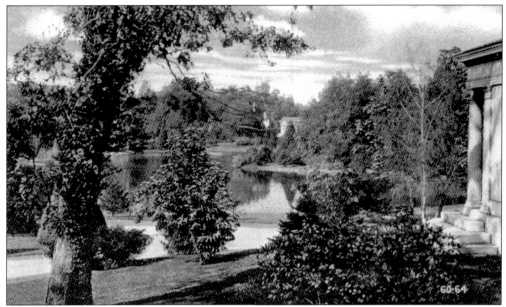

While not a traditional park, Harleigh Cemetery was formed in 1885 and laid out in a park-like fashion to inspire visitors to stroll the lush grounds. The graveyard, where Camden luminaries such as Walt Whitman were laid to rest, was designed as a series of lawns with interlocking drives and carefully grouped trees and shrubs. While monuments were welcome, headstones and footstones were limited to eight inches in height to preserve the open feel.

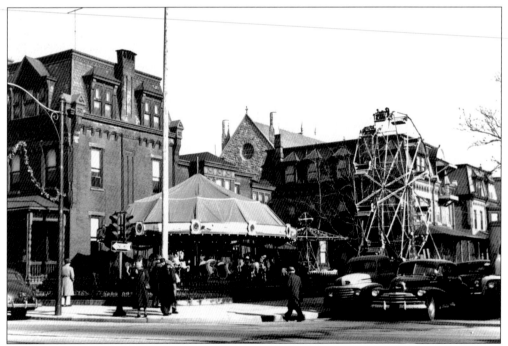

At one time or another, entertainment could be found on virtually any street corner in the city, like this temporary carnival squeezed into a small vacant lot in the winter of 1952. (Courtesy Haddonfield Public Library.)

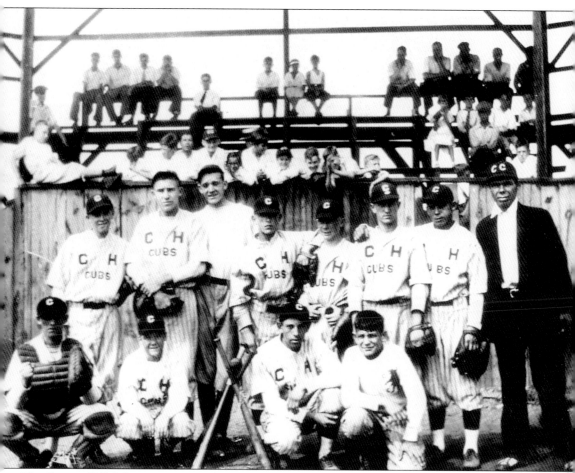

The Cramer Hill Cubs were just one of several local teams that provided Camden sports enthusiasts with home-grown entertainment, often drawing as many as 1,500 screaming fans to their games in the days before television. Pictured here in 1931 on their home field are Kaiser Bauer, Tom Goldy Jr., Lou Bobo, Louie Doerr, Bill Baughman, Wiz Zimmer, Larnie Cassidy, Soapy Swartz, Dickie Weiss, Walt Heartling, Joe Straub, and Tom Goldy Sr. (Courtesy B. J. Swartz.)

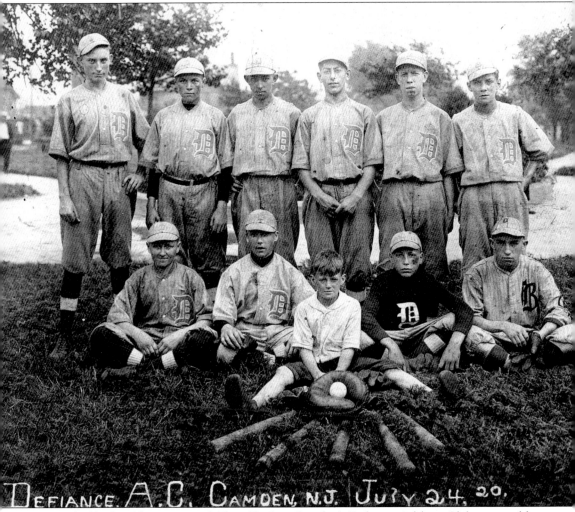

DEFIANCE A.C. CAMDEN, N.J. JULY 24, 20.

Backed by local businessman Milton Kooker, Camden's Defiance Athletic Club, pictured here in 1920, was recognized in the *A. J. Reach Official American League Guide* when the semi-professional team closed the 1923 season with a record of 32 wins, 8 losses, and 3 ties. Players earned a whopping $125 to $200 a game when the team was in top form. Four years after the club's winning 1923 season, Camden nearly scored big again, when Philadelphia Athletics owner Benjamin Shibe considered relocating his American League team to the city so they could play on Sundays. (Courtesy B. J. Swartz.)

Camden residents had to travel by ferry to Philadelphia and then walk three miles to get to a Polish parish before St. Joseph's Parish was formed and began renting a building off Broadway in 1892. The first church, pictured here, was built in 1895 at Tenth and Liberty Streets. The dedicated parishioners dug the building's foundation themselves. (Courtesy St. Joseph's Church.)

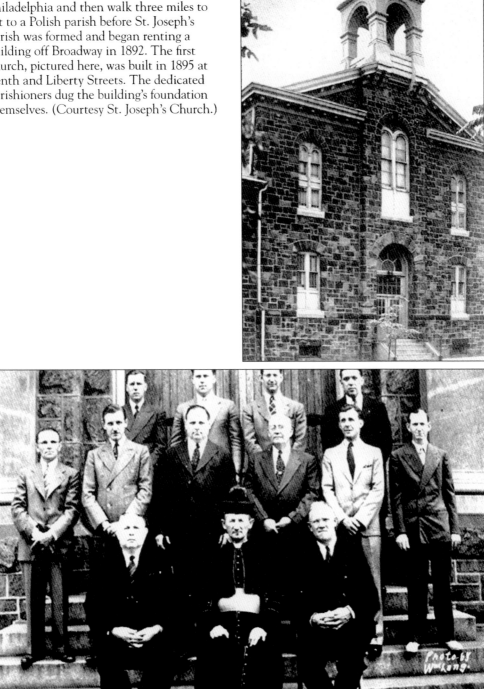

The 1942 trustees of St. Joseph's Parish pose on the steps of their new church with Rev. Arthur B. Strenski, who by that time was leading a congregation of close to 12,000. During their tenure, the parish sent 1,630 young men and women to serve the country in World War II. A total of 37 men were killed in battle. (Courtesy St. Joseph's Church.)

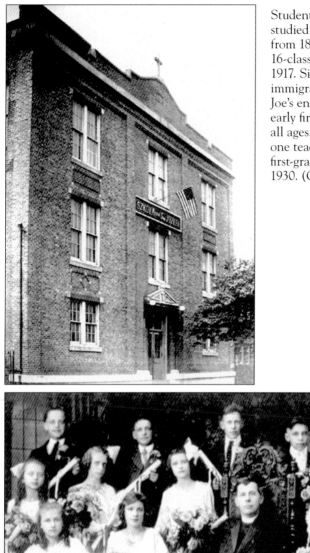

Students of St. Joseph's Parochial School studied in the lower level of the church from 1895 until this new three-story, 16-classroom school was constructed in 1917. Since most parishioners were recent immigrants, enrolling their children in St. Joe's ensured they would learn English, and early first-grade classes included children of all ages. The school's popularity resulted in one teacher being assigned to over 100 first-graders each year between 1903 and 1930. (Courtesy St. Joseph's Church.)

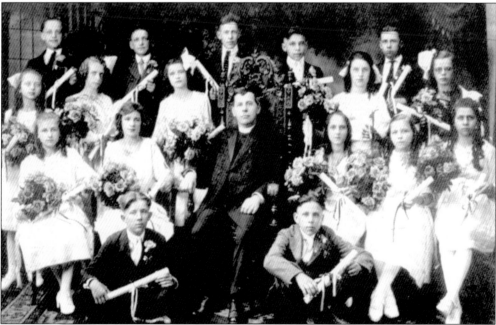

The graduating class of 1922 poses with Rev. Stefan Wierzynski. Pictured here are A. Roszkowiak, S. Gawronski, B. Wisniewski, J. Bartoszek, C. Kasprzak, C. Ziobro, C. Busz, S. Makowska, S. Pawlak, A. Konieczka, G. Anyzek, L, Kryza, M. Brzozowska, W. Serba, H. Wapinska, J. Stronski, and S. Pawelek. (Courtesy St. Joseph's Church.)

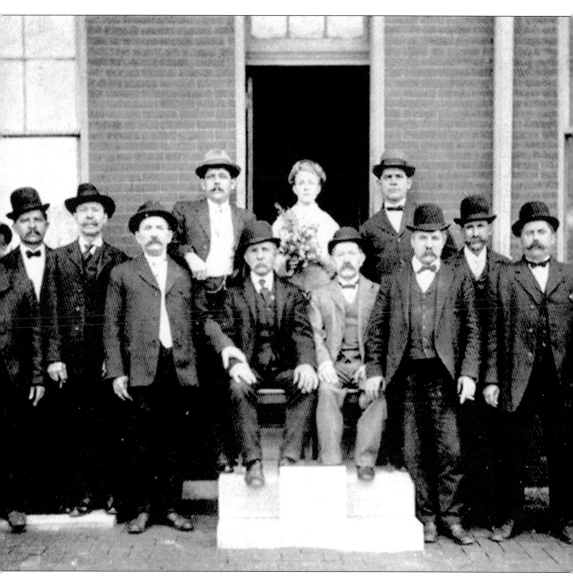

Founded in 1896, the T. Kosciuszko Building and Loan Association helped the Polish community purchase homes in Camden. Pictured here are most of the association's organizers and first officers: (from left to right) Stanislaw Lubonski, Albert Siuda, Valentine Meksa, Stanislaw Burzynski, John Siuda, Adalbert Mazur, unidentified, Adalbert Florkowski, Francis Siuda, Feliz Jaroch, Adalbert Zajac, Stanislaw Dera, and Martin Mikolajczak. (Courtesy St. Joseph's Church.)

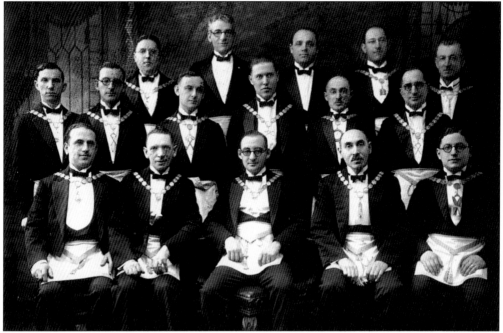

The 1925 officers of Camden's Mizpah Lodge pose for a portrait. The Masonic members included Reuben Pinsky, Raymond Mowers, Charles Blombaum, Benjamin Young, Meyer Borstein, Norman Wessel, Maurice Wessel, Robert Banscher, Joseph Rickler, Israel Heine, Leon Faerber, Jacob Hernfeld, Milton Manheimer, Calvin Schneeberg, and Morris Matt. (Courtesy Tri-County Jewish Historical Society.)

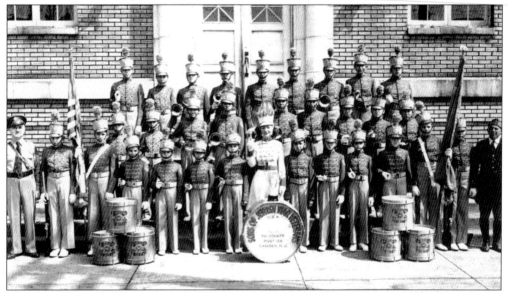

Posing in front of the Talmud Torah building, at 621 Kaighn Avenue, the drum and bugle corps of the Camden-based Tri-County Post 126 of the Sons of Jewish War Veterans prepares to march off to a parade in 1949. The school was established to ensure the American-born children of Jewish immigrants would receive a good religious education. (Courtesy Tri-County Jewish Historical Society.)

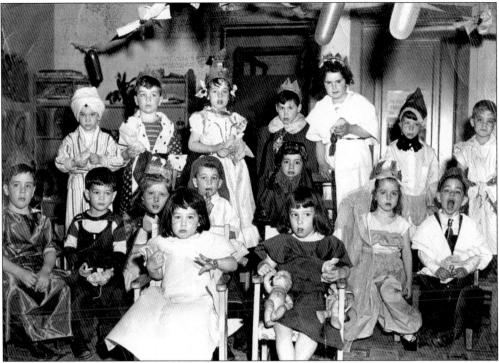

Shown here is Camden's first Jewish nursery school class dressed for Purim in 1948. (Courtesy Tri-County Jewish Historical Society.)

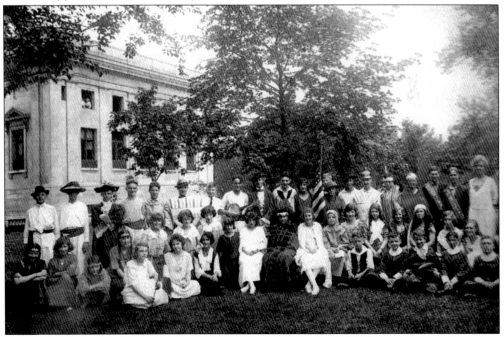

Young congregation members of the North Baptist Church, founded in 1859 at 317 Linden Street, pose for a photograph around 1918, during a special celebration. (Courtesy Camden County Historical Society.)

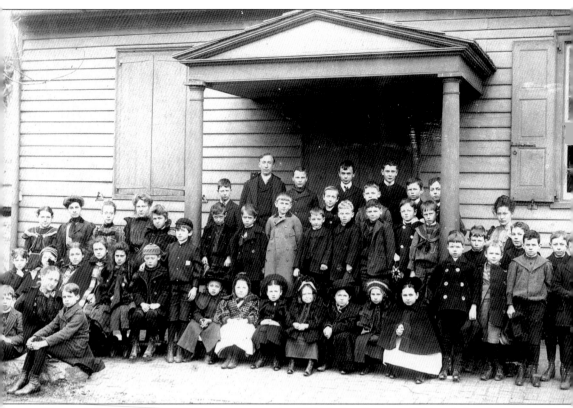

The small Camden Friends School was erected at 709 Market Street in 1794 and closed its doors in the 1940s. This photograph of the Quaker-educated private school students was taken in March 1900 and includes (in no specific order) Alfred Cook, Arnie Stiles, Lilian Fogg, Myrtle Koin, Agnew Irwin, Etta Comey, Eva Heritage, Miriam Comey, Adele Stockham, Adam Pfeiffer, Charles Stisels, Mary Parson, Charles Zane, Eleanor Moore, Ervin Mitchell, Charles Hudson, Sarah Webster, Reed Hirst, Fred Veser, Alice Morton, Elsie Wood, and teachers Miss Rogers and Miss Collings. (Courtesy Camden County Historical Society.)

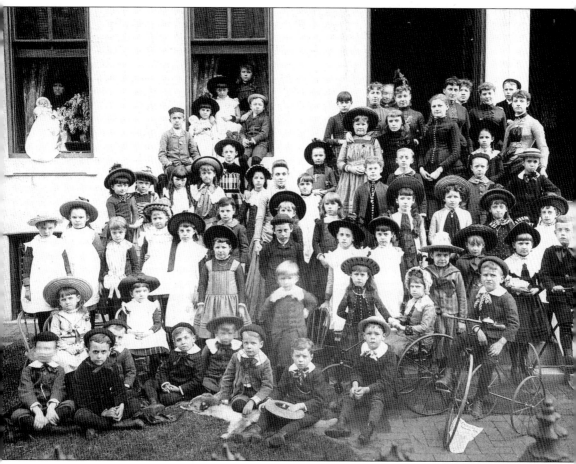

Camden students could also attend the private Raymond Academy, which opened in 1886 on Linden Street below Fifth Street. Early students, pictured here shortly after the school's opening, included (first row) Harry Rohrer, Charles Seymour, Malcolm Shelmire, Harry Griffith, Russell G?, George Spooner, Laurence Dudley, and Herbert ? on his bicycle. In the upper right doorway stand several of the school's teachers, including Miss Bunnell, Mrs. Northrop, and Mary Northrop. The baby in the upper left window is Charley Maloney. Other students include (in no specific order) Nellie Hogan, Helen Fagans, Velma Turner, Helen Braddock, Martie Goldy, Marian Scull, Howard Pancoast, Mazie Davidson, Florie Vanneman, Anna Ayer, Marjorie and Nelson Thayer, Tom Potter, Mary Prickett, Ira Birdsall, Helen Shelmire, Dora and Julia Williams, Richie Jenkins, Ada Woodward, Anna and Alice Doughten, Jean Carson, Mary Campbell, Horace Bryan, Edna Starr, Sara Sewell, Ollie Scull, Helen White, Mabel Hurff, and Henrietta Joslin. (Courtesy Camden County Historical Society.)

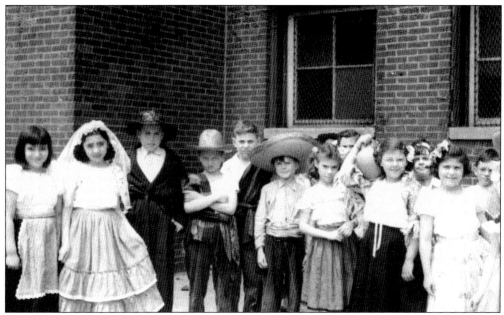

Third-grade students at Parkside School show off homemade costumes in the schoolyard before participating in a play as part of a lesson on Mexico in 1948. Due to the city's ethnic diversity, geography lessons often included activities such as learning songs in a country's language and dressing in traditional costumes. Pictured from left to right are Erna Levinson, Mary Albanese, Richard Wilkie, unknown, Larry Phillips, unknown, Carol Bitman, Christine Curcio, unknown, Nadine Kellman, and Michael Teitelman.

Greek Week is in full swing in this photograph of fraternity members parading through the city streets in 1964. (Courtesy Rutgers University-Camden.)

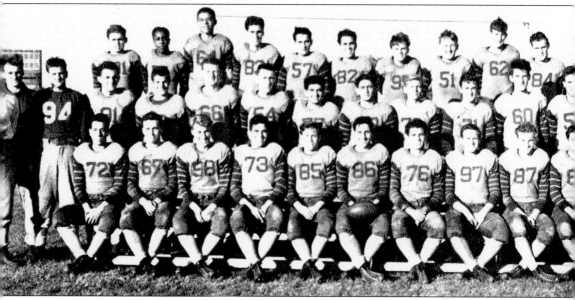

Always raring to meet the opposition, the 1947 Camden High School football team included, from left to right, (front row) J. Santanello, J. Moran, D. Doroszko, A. Terranova, H. Goff, E. Cipriani, J. Caprarola, S. Szwak, E. Kitlas, and future Camden mayor A. Errichetti; (second row) Coach Walt Nowak, assistant coaches C. Weber and A. Litwa, J. Melfi, T. Bonelli, W. Wilcox, F. Coskey, T. Pontelandolfo, C. Caprice, E. Proroki, F. Wasiski, F. Phillips, and J. Vespe; (third row) V. Cuneo, E. Brown, G. Thomas, R. Read, J. Abbott, R. Pugliese, T. Wisniewski, C. Sobolowski, E. Moffa, B. Levinson, and A. Harvey.

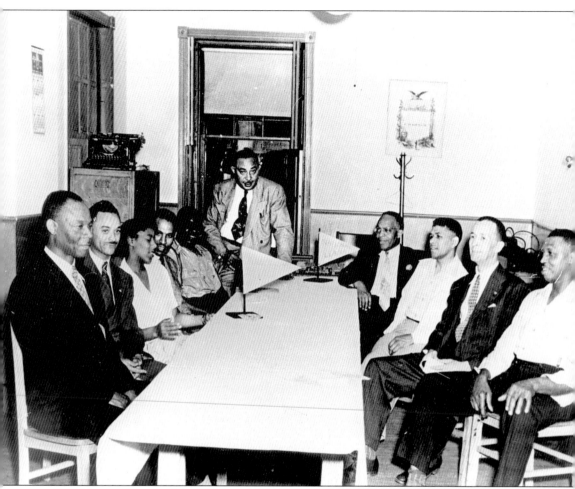

The Hunton Branch of the YMCA (later renamed the South Camden Branch) was constructed at Liberty and Sixth Streets in 1920 by prominent citizens of the black community when the city's institutions were segregated. The Frances Harper Branch of the YWCA for Colored Women was located at 822 Kaighn Avenue. Pictured here during a meeting at the YMCA are (from left to right) Dr. Howard W. Brown (chair of the YMCA management committee), William R. Knighton (a YMCA officer), three unknown people, Albert K. Flournoy (YMCA executive secretary), two unknown people, George Eggleston (Whitter School principal), and an unknown person. (Courtesy Camden County Historical Society.)

Eight

ON THE TOWN

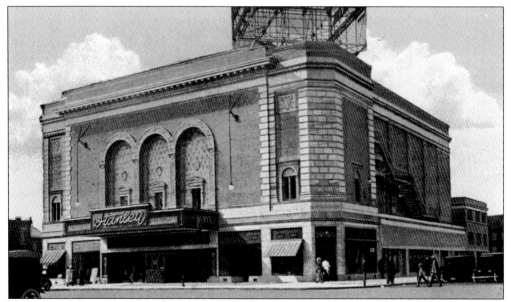

The Stanley Theatre, at the corner of Broadway and Market Street, was the largest motion picture house in the world when it opened. New York mayor Jimmy Walker led the gala celebration when the $1 million theater opened on February 19, 1926. Offering both live shows and motion pictures, an average summer show in the air-conditioned movie house cost 25¢ and included a five-act live stage show and a double feature.

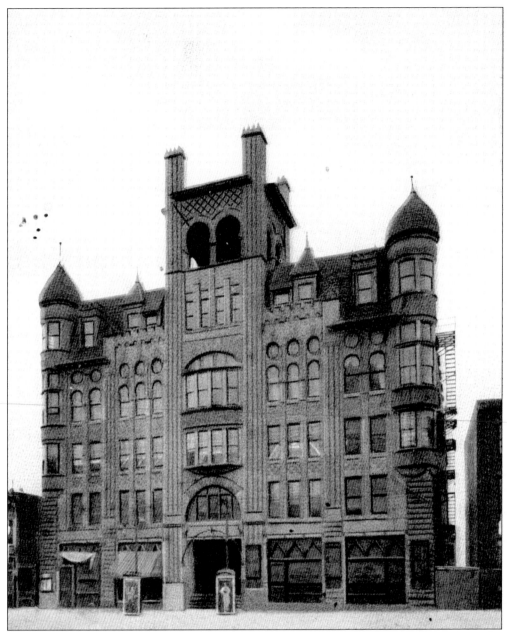

The Camden Theater opened in 1892, providing residents with an alternative to taking the ferry to Philadelphia for quality entertainment. Located at Fourth and Market Streets, the theater hosted many of the leading performers of the day in impressive productions. In 1893, a Shakespearean group played to a sold-out house on eight consecutive nights, and throughout the 1890s, *Uncle Tom's Cabin* remained a favorite, especially during a run where promoters sponsored a three-round professional boxing match at intermission. During the 1893 depression, the region's social elite, decked out in stunning gowns and long-tailed coats, raised donations for the less fortunate by attending concerts, and attended charity balls benefiting women's and other organizations. The building also served as the Masonic temple until the Masons built a new facility in 1913.

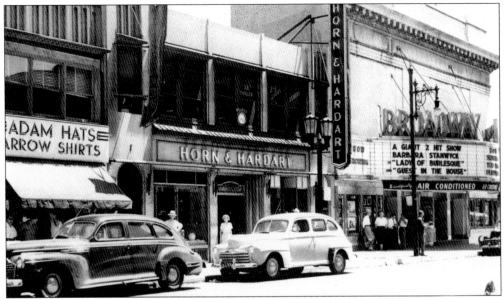

The Broadway Theater, at Broadway and Carmen Street, and the Horn and Hardart Cafeteria and Automat were just two popular downtown destinations in 1949. In January 1951, the theater, renamed the Midway, hosted the first East Coast showing of *The Wild Blue Yonder*. The film's stars never made their scheduled appearance, but management did receive letters of congratulations from such Hollywood luminaries as Bing Crosby, John Wayne, and Ester Williams. (Courtesy Haddonfield Public Library.)

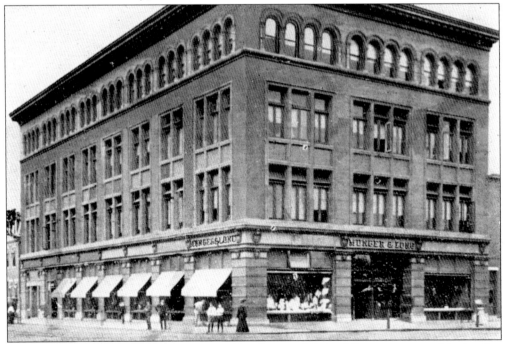

The Munger and Long department store at Broadway and Federal Street was one of the leading retailers of its time and the city's first modern department store. Opening in 1904, the building was sold to J. C. Penney in 1934 and continued drawing savvy shoppers.

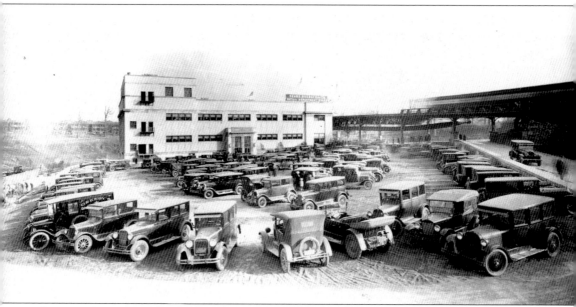

Opening day at Sears, Roebuck and Company's new Camden store on Bridge Boulevard (later renamed Admiral Wilson Boulevard) drew record crowds in the summer of 1927. Camden's first $1 million structure, the Sears building was constructed on the site of the former Camden Iron Works and served as an anchor for the scenic route lined with posh shops and restaurants that connected the city and the suburbs. (Courtesy Sears, Roebuck and Company.)

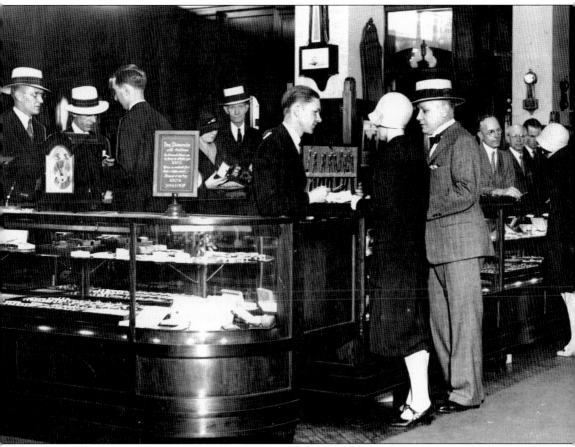

The grand opening of Pinsky's department store at Broadway and Spruce Street in 1924 drew scores of shoppers already familiar with the Pinsky name. Harry Pinsky opened a furniture store in the city in 1891 and turned the operation over to his son Rueben in 1906. Under his leadership, the businesses gained a reputation for quality merchandise and service. The department store closed during the Great Depression, but the furniture business remained on Broadway into the 1950s. (Courtesy Tri-County Jewish Historical Society.)

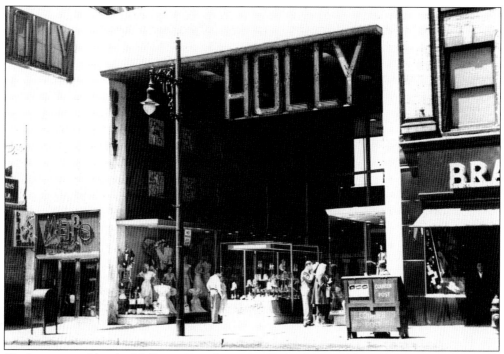

Clothing stores like the Holly, on Broadway near Federal Street, drew shoppers from the city and surrounding suburbs to Camden's bustling downtown district, offering the latest in quality merchandise in the 1940s and 1950s. (Courtesy Haddonfield Public Library.)

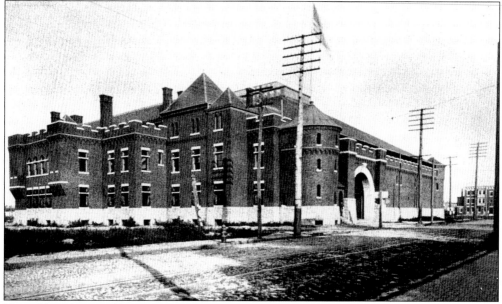

Viewed here from Haddon Avenue and Benson Street, the Third Regiment Armory, built in 1896, was one of several sites overflowing with sick residents during the 1918 influenza epidemic. The armory hosted events such as speeches by Pres. William Taft and former Pres. Theodore Roosevelt in 1912. It later served as Camden's second convention hall, hosting the Camden Bullets' professional basketball games, roller derby tournaments, and professional wrestling matches.

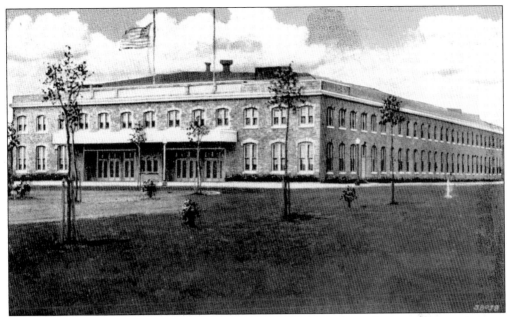

Camden's convention hall, at Line Street and Memorial Avenue, hosted sporting, entertainment, business, and civic events. Opened with a formal banquet in December 1925, the civic center was destroyed by fire in 1953. One of the last series of events held in the facility was a live television show featuring circus acts, called Big Top.

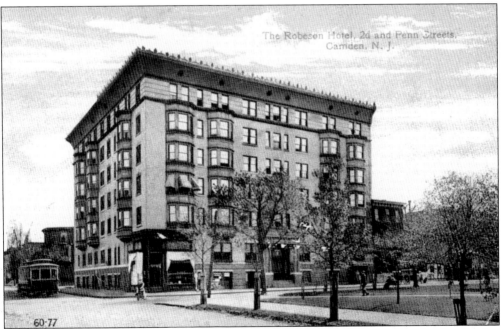

The Robeson Hotel at Second and Penn Streets was just one of many Camden hotels that flourished in the first half of the 20th century. By 1940, the establishment had been renamed the Hotel Camden and was competing for business with over 30 other hotels and apartment houses in the city.

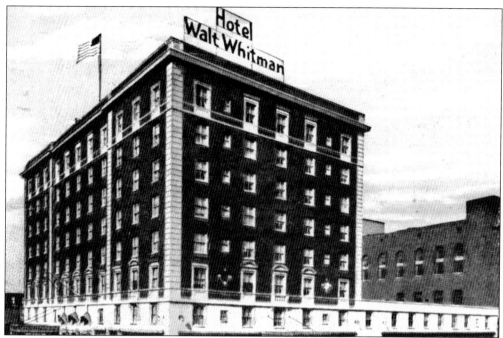

Funds to construct the eight-story brick and stone Walt Whitman Hotel, at Broadway and Cooper Street, were raised through public subscriptions collected by neighborhood teams in the name of the Community Hotel Corporation. The group had no trouble raising the $1.25 million needed to construct and furnish the building, which provided luxury accommodations for the city's many visitors when it opened in 1925.

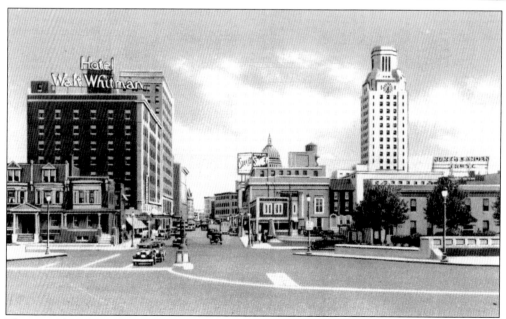

The exit plaza from the Delaware River Bridge (foreground) steered Philadelphia visitors to the Walt Whitman Hotel and the heart of Camden's booming downtown district, shown here around 1940.

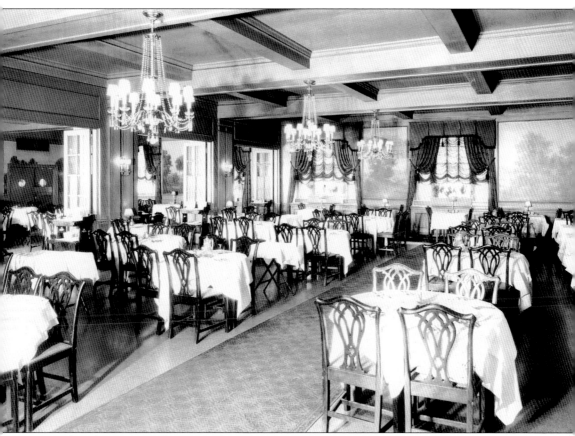

The Walt Whitman Hotel was Camden's first luxury hotel when it opened in 1925. Beyond its fine rooms, the hotel boasted an elegant ballroom and excellent dining accommodations. The dining room seen here was the scene of countless weddings, society dinners, and fund-raising events throughout the years. The grand hotel was already thriving by the time the Delaware River Bridge opened in 1926. It was demolished in 1977 to make way for a parking lot. (Courtesy Camden County Historical Society.)

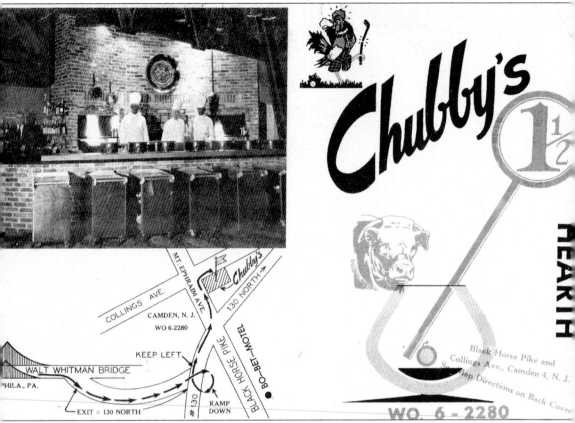

Chubby's 1½ Hearth, at the Black Horse Pike and Collings Avenue, operated from 1934 through 1995 in the Fairview section of the city. Known for its delicious charcoal-grilled steaks and shrimp, large one-and-a-half-shot drinks, and exceptional service, Chubby's catered to a well-dressed clientele.

Nine

NEWSMAKERS

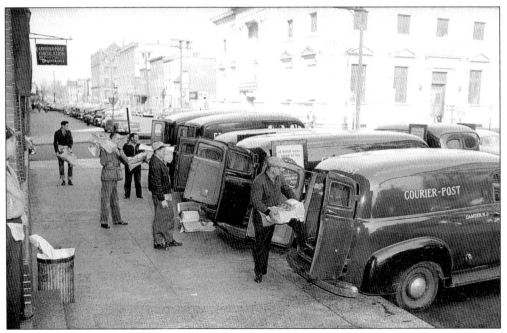

Workers load *Courier-Post* delivery trucks at the newspaper's headquarters at Third and Federal Streets around 1950. Founded in Camden in 1875, for years the *Courier-Post* was one of several newspapers based in the city. The newspaper moved to the suburbs in nearby Cherry Hill in 1956. (Courtesy Courier Post Library.)

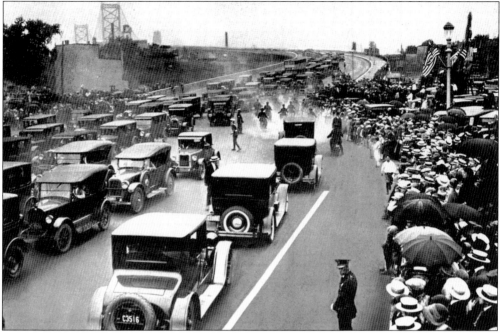

A crowd of 30,000 flanks the roadway as Pres. Calvin Coolidge's motorcade advances along the Delaware River Bridge during its official dedication on the afternoon of July 5, 1926. Curious Camden residents stood in the pouring rain for hours to catch a glimpse of the president. During the soggy ceremony, Coolidge stayed dry by borrowing a raincoat from a city police sergeant who reportedly never saw the garment again. (Courtesy Delaware River Port Authority.)

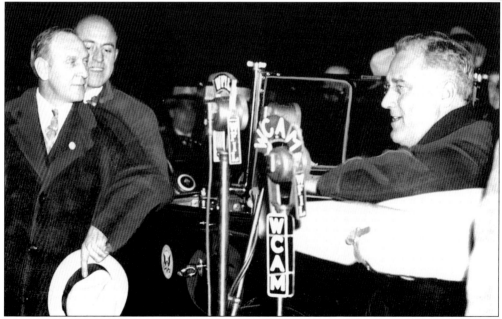

Pres. Franklin D. Roosevelt made several trips to Camden in the 1930s and 1940s. Over the years, presidents and presidential hopefuls, including William McKinley, Harry Truman, John F. Kennedy, Richard Nixon, and Dwight D. Eisenhower, visited the city. (Courtesy Courier Post Library.)

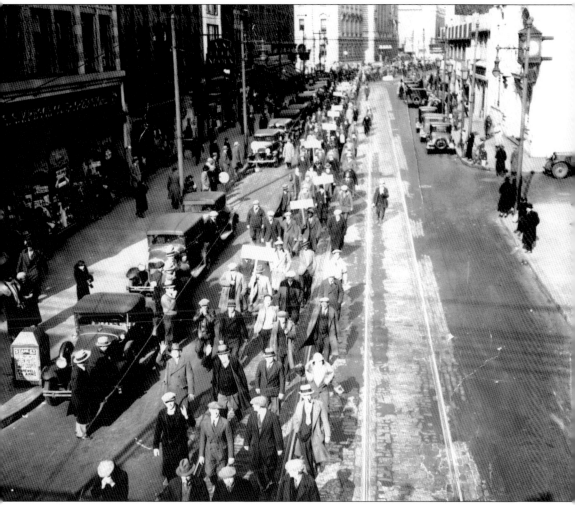

Unemployed workers desperate for jobs march down South Broadway around 1935, a typical scene that played out across the country during the Great Depression. With an extremely strong industrial base, Camden residents may have fared better than workers in some other parts of the country, but many still lost their jobs or experienced substantial pay cuts. To help ease the hardship faced by Camden families, the Wiley Mission Methodist Episcopal Church provided relief to the unemployed and the city's Freihofer Baking Company donated bread to the hungry. (Courtesy Franklin D. Roosevelt Library, Public Domain Photographs.)

A number of homes were seriously damaged and several people were injured when a cyclone hit the northern section of the city on April 2, 1912. A deluge of damaging rain pounded the area some time after the devastating storm. The area affected by the heavy winds ran from Pearl Street to State Street and from the Delaware River to the Cooper River. (Courtesy Camden County Historical Society.)

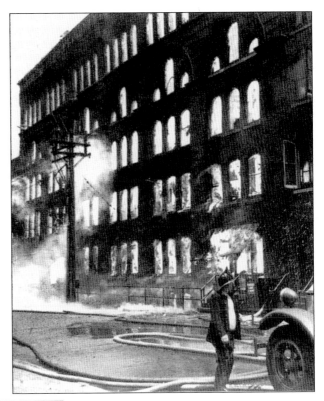

The R. M. Hollingshead Chemical Plant, between Ninth and Tenth Streets at Market Street, erupted into flames on July 30, 1940, following an early afternoon explosion. The inferno, which is believed to have been the result of excessive summer heat causing some of the company's flammable products to ignite, was considered the worst fire in Camden's history. Raging for several days, it left 10 workers and one firefighter dead, 200 treated at area hospitals, and 400 homeless. The blaze caused $1 million in damage to surrounding homes and businesses. (Courtesy City of Camden.)

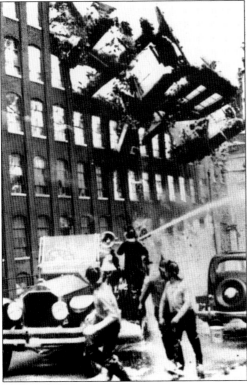

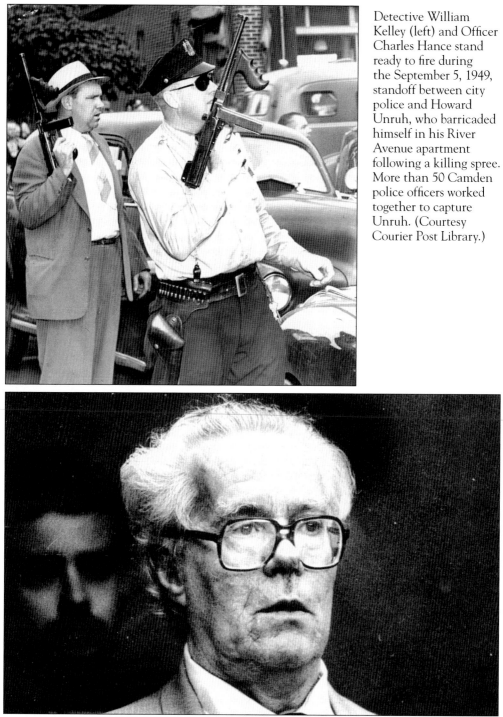

Detective William Kelley (left) and Officer Charles Hance stand ready to fire during the September 5, 1949, standoff between city police and Howard Unruh, who barricaded himself in his River Avenue apartment following a killing spree. More than 50 Camden police officers worked together to capture Unruh. (Courtesy Courier Post Library.)

Considered to be the nation's first mass murderer, Camden resident Howard Unruh killed 13 people and wounded three others during his 1949 rampage. Photographed here at a 1989 mental health hearing, he was sentenced to a maximum-security facility for the criminally insane in 1949. (Courtesy Courier Post Library.)

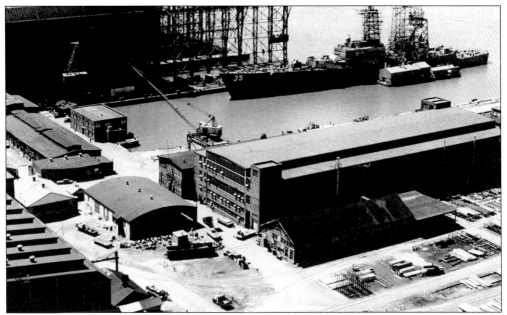

Plagued by poor management and increasing environmental concerns, New York Shipbuilding closed its doors in South Camden 65 years after its illustrious opening. The shipyard's closing in the spring of 1965 added one more nail to the city's coffin. (Courtesy Catholic Star Herald.)

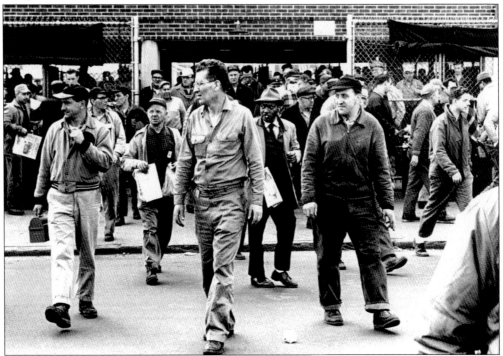

As the final shift at New York Shipbuilding came to an end, workers poured through the gates and into the city streets in May 1965. The one-time industrial giant's final payroll included a mere 500 workers, a far cry from the 33,000 employed during World War II. (Courtesy Catholic Star Herald.)

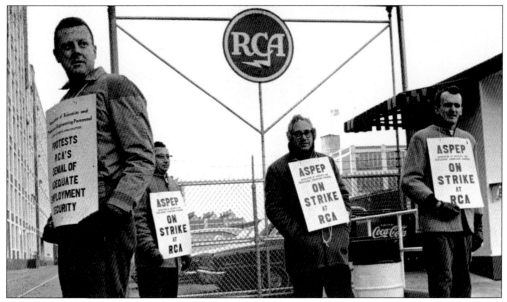

Camden's RCA workers hit the picket lines over job security in December 1967. The city's workforce first began making its demands known by striking in 1933, when Congress Cigar Company's female employees walked out of the factory at Ninth and Liberty Streets, causing riots in South Camden. The following year, Campbell Soup employees followed suit, and in 1935, New York Shipbuilding workers took part in a three-month work stoppage. (Courtesy Catholic Star Herald.)

Actress and peace activist Jane Fonda urges students at Rutgers University's Camden campus to continue opposing the Vietnam War during an afternoon peace rally on Veteran's Day 1970. The November rally took place in front of the North Baptist Church, which was used as a campus fellowship and gathering center. (Courtesy Catholic Star Herald.)